IMAGES
of America

UINTAH

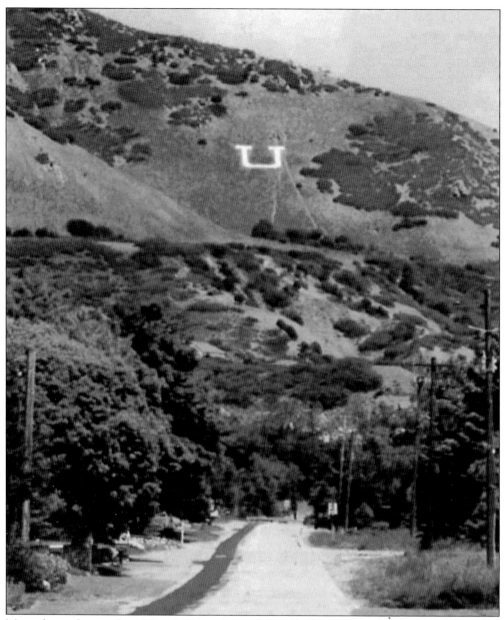

Many do not know where Uintah City is located, but the historical "U" on the mountainside, which has existed since April 28, 1923, is well known. It has served as a landmark to the U.S. Air Force to guide pilots returning from the practice range, as its location is almost perfectly in line with the base leg of their landing pattern. Its history holds a special place in the hearts of the Uintah citizens and others who have kin that lived here, previous citizens, those that live here now, and all those whose hearts are tied to Uintah in some fashion. (Courtesy of Uintah Historical Files.)

ON THE COVER: This picture, taken in the late 1920s, is of an entry from Uintah that was in the Ogden City parade, which was held on July 24. Pictured from left to right are Melvin Bybee (back cover), Elmo Hamre, and John Gale. (Courtesy of Uintah Historical Files.)

IMAGES
of America

UINTAH

Sue Bybee

ARCADIA
PUBLISHING

Published by Arcadia Publishing
Charleston SC, Chicago IL, Portsmouth NH, San Francisco CA

Printed in the United States of America

Library of Congress Control Number: 2009943319

For all general information contact Arcadia Publishing at:
Telephone 843-853-2070
Fax 843-853-0044
E-mail sales@arcadiapublishing.com
For customer service and orders:
Toll-Free 1-888-313-2665

Visit us on the Internet at www.arcadiapublishing.com

To my family and friends, who are my inspiration in everything.
And to everyone who loves Uintah and its history
for teaching me that great things are born from tiny sparks of inspiration.

CONTENTS

ACKNOWLEDGMENTS

I am grateful to my dear husband and our loving daughters, who have always encouraged me through the many projects that I have taken on. They have always been there for me. I am also grateful for my grandchildren, who want to know more, and to those that ask the hard questions that have given me the opportunity to research and learn the answers.

I am indebted to the many individuals that have saved, gathered, shared, and given the many stories and information about the community's history and their ancestors in manuscript, photographs, and printed sources to Uintah's History Collection. Unless otherwise noted, all images appearing in this book were provided through Uintah's History Collection. Without these contributions, this book would not have been possible. Special thanks goes to those that have helped me find those special pictures and information that helped complete the book: Carolyn Barnes, Beverly Bingham, Dave and Donna Boothe, Janice Bryson, Grant Bybee, Jim and Sherry Bybee, Phyllis Dolan, Neil and Leora Dye, Rulon Dye, Issac Goeckeritz, Lenard and Betty Kendell, Ivy Keyes, Jean Knudson, Scott and Kisten Knudson, Cheryl Peters, Dixon Pitcher, Bruce Smith, James Stoddard, Claude Stuart, Elliott and Fay Stuart, Marion Stuart, Mark Stuart, and Rich Stuart.

I would like to acknowledge and give special thanks to Donna Boothe, Suzette Bybee, and Bruce Bybee for all the work and time that they spent providing a valuable service of reviewing, editing, and asking the hard questions to clarify information.

I would like to thank Jared Jackson at Arcadia Publishing, who first approached me with the idea for the book on Uintah. And I would like to especially thank Hannah Carney, my editor and critic with an abundance of talent and patience, who guided and prodded me along through the process.

INTRODUCTION

The first permanent Mormon pioneer settlers arrived in 1850. They found that the area was wild but offered an abundance of water, wildlife, and flat, fertile ground boasting numerous indigenous, edible plants. The land was covered with bunch grass that was rich and provided food for their cattle. Oxen were used to till the land, and the implements that they used to farm with were very poor. The soil was productive, and they realized a good harvest. They used native material, cut branches from the Weber River, hauled logs from the mountains to make their homes, and worked together to build the settlement. They learned to live with the Native Americans that had previously roamed the land.

The pioneers knew that access to water was crucially important, and they started work right away on a small stream called Spring Creek, which unites with the Weber River at the mouth of Weber Canyon. Construction of the Pioneer Canal was started in 1852 and was completed in 1853. River Ditch, now known as the Uintah Central Canal, was built during 1856 and 1857.

Those early settlers also erected a log building that was used for both a schoolhouse and church meetings. Textbooks used in the school were histories of the United States, the Bible, the Book of Mormon, and the Doctrine and Covenants. A good slate was considered quite a valuable piece of property, as there were no tablets or blackboards for use in the home or in the schools.

In the fall of 1852, the settlement was given the name of East Weber. The community was surveyed by Jesse Fox, the territorial surveyor. Tracts were "layed" out in 80-acre plots, with streets running at right angles. What are now known as 6600 South and 6550 South were the main streets, with four cross streets running north and south. A provincial form of government from the United States was put into place throughout the state. The state had also been organized into counties, precincts, and so on.

From 1853 to 1862, the small settlement suffered three attacks. First, as relations became tense with the Ute Indians, there was a scare of an uprising, later known as the Walker War. The Uintah Fort was built for protection from the Native Americans. As these troubles quieted down, the fort was no longer needed. Next was the approach of Johnston's Army in the latter part of 1857. Four companies of men were sent to Echo Canyon to assist in protecting the settlers against their enemies. In 1862, the settlement was in the middle of an armed conflict that became known as the Morrisites War.

By order of the county court in 1867, the name of East Weber was changed to Easton. At this time, around 20 families were in the area. On March 2, 1869, along with the first whistle of a locomotive coming through Weber Canyon, the town of Easton quickly became a wild and woolly boomtown with more than 100 businesses and a population around 5,000. A railroad station was constructed in 1869, with the name of Deseret. To avoid the confusion of having a railroad station and post office named Uintah in a town known as Easton, the settlement was named Uintah after the local Shoshone Indians.

In 1870, a circulating library was established in the schoolhouse, which also served as a social hall and church meeting place. In 1872, the Utah Central Railroad opened between Salt Lake City and Ogden, and Uintah's boom period was over. Almost overnight, residents, business owners, and freighters deserted the town. Uintah became an agricultural area once again.

The Uintah Canning Factory was built in 1901 and became the first major business in Uintah, providing jobs to many in town. The canning factory handled locally grown fruits and tomatoes, and was in operation until 1924. Despite building activities, Uintah experienced little growth in population, and by 1900, less than 300 people lived in Uintah.

During the years from 1919 to 1922, trouble at the little schoolhouse in the valley began to build between the principal and the older youth. Trouble erupted when the principal, Marlow J. Christensen, shot and killed William Lloyd Bybee, a 19-year-old student. That incident divided the town. In 1922, A. Golden Kilburn was hired as the new principal, and he worked hard to bring the town back together and to make Uintah united again.

Golden came up with the idea of putting a "U" on the side of the mountain. The "U" would represent Uintah, their town; united, for what the town would become; Utah, their state; and for the United States, the country they lived in. Golden worked with the boys to form a scout troop, and Claude Elliott Stuart Sr. became the scoutmaster. With the help of Bishop Charles Fernelius, the scouts, and landowners, the mountainside "U" became a community project. Joseph Orin Bybee agreed to construct the "U" on his land, and Byram Lee (Bine) Bybee agreed to construct the right-of-way to the "U" on his land. Each year, an event known as U-Day celebrates the reunification of the town with events and the lighting of the historic "U."

The town was still an unincorporated area of Weber County in 1930, but the need for a modern water system was acute, since many of the families were carrying water for culinary use and leaving the irrigation water for other purposes. On February 10, 1937, the area became incorporated, and the town's name, Uintah, was retained. A water system was soon installed at the cost of $20,000. This system was upgraded in 1959. With the improvement of the city water supply, a multiuse park was developed in 1965. The park's baseball diamond has seen a large amount of use since baseball and softball have always been favorite sports of the city's people.

A water bond election was held and passed in 1970; this opened the way to enlarge the town water system. Agreements were also signed to add Weber Basin water to the town's system to ensure an adequate supply. With the assurance of an adequate water supply, many improvements were made to the town. The population of Uintah has grown from approximately 400 in 1974 to more than 1,400 in 2005. The Town of Uintah officially became Uintah City in November 2000, when its population reached the required number.

Uintah is home to a few well-known businesses, some international businesses, and several family-owned businesses that make Uintah's business scene unique. City improvements have been numerous during the last 10 years. The Uintah Memorial Park and monument honoring Uintah's past and great citizens was added in 2003. Landscaping with signs has been added to the entrances to the city. A new Uintah City Hall was constructed in 2008. As we continue to move forward, the city's effort to remain a primarily rural area is being tested, as many of the old farms are being divided for development. Uintah is a strong community with a rich history that will live on for many years.

One

EAST WEBER TO UINTAH

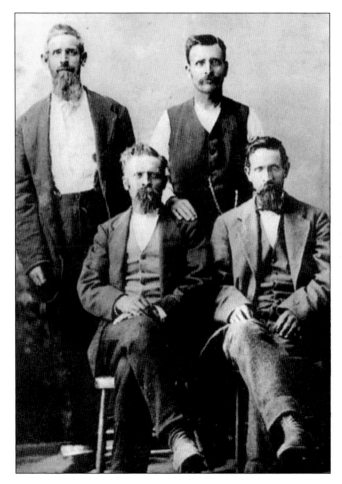

Pictured here are the Bybee brothers, from left to right, (seated) David and Byram Levi; (standing) John McCann and Robert. John McCann arrived first after his release from the Mormon Battalion. Byram Levi was a sharpshooter, hunter, and Native American interpreter, and in 1852, he acted as presiding ecclesiastical officer of the Church of Jesus Christ of Latter-day Saints (LDS). In 1854, he was appointed the first justice of the peace, with the duty to warn the Native Americans not to shoot deer without making good use of the meat.

Another early settler, Daniel Smith, was never happier than the day he arrived, although he found it a terribly lonesome and desolate place. At first, the mountain men offered $1,000 for the first ear of corn or bushel of wheat that was raised in the valley. Soon the people prospered, the valley bloomed like a rose, and grain, vegetables, and fruit grew in abundance.

Abiah Wadsworth was appointed the presiding ecclesiastical officer for the Church of Jesus Christ of Latter-day Saints from 1852 to 1854. In the spring of 1853, a sawmill was erected by Abiah Wadsworth, Henry Beckstead, and Nelson Arave. Its efficiency could be gauged from the remark of an old pioneer, who wished he had a lease on life until he could saw enough wood for his coffin. However, the mill proved to be quite successful and produced a considerable amount of wood.

Henry Beckstead settled in East Weber in 1850 and built the first bridge across the Weber River. He assisted in the effort to stop Johnston's Army from coming into the valley by stampeding the cattle. In 1887, he was arrested for polygamy and was released in 1888. His spirit and health were broken while in prison, and he died six months after he was freed.

Edmund Orson Wattis Sr. married Mary Jane Corey in 1852, soon after his arrival, and they raised their family in East Weber. Wattis was appointed the presiding ecclesiastical officer for the Church of Jesus Christ of Latter-day Saints from 1866 to 1867. His initial freight-hauling venture started in 1867, during the boom days. In 1881, the Wattis brothers (Edmund Orson, George Lyman, and William Henry) undertook their first construction project with the Corey brothers (Warren, George, and Charles). Together they became well known as railroad contractors.

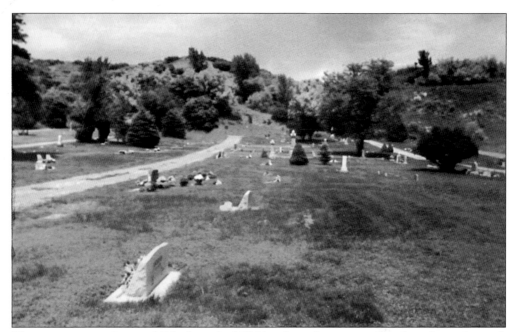

The cemetery was first established on the hillside where the upper railroad tracks are located. It was relocated to its present location in 1911 and was under the responsibility of the presiding ecclesiastical officer of the Church of Jesus Christ of Latter-day Saints. It is believed that the first person buried in the cemetery was a Native American. Levinas Jones, buried in 1865, is the oldest known death. The only veteran from the Mexican War, John M. Bybee, died in 1909. Coffins for older people were black trimmed with white, while white coffins trimmed with black were for those that were younger. The diphtheria epidemic of 1876 resulted in families losing two or three children, mostly girls from a Church of Jesus Christ of Latter-day Saints Sunday school class.

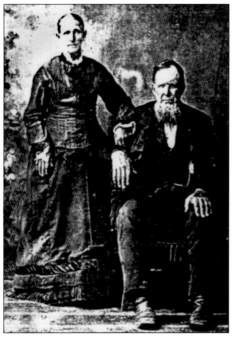

Levi and Polly Hammon arrived in the area in 1852. Levi worked on the East Weber fort to protect citizens from Native Americans. In the spring of 1854, he helped dig a canal to get water from the Weber River for irrigating. Two years later, he helped build the River Ditch, now known as the Uintah Central Canal. In the winter of 1857, when Johnston's Army threatened the settlers, he spent three months at Echo Canyon as a guard and scout helping protect the members of the Church of Jesus Christ of Latter-day Saints from Johnston's Army.

The first schoolhouse was built in 1850 and was constructed of logs with a dirt floor and roof. The first teacher was William G. McMullin. This little schoolhouse was replaced in 1855.

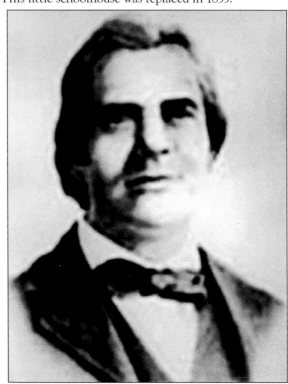

On April 29, 1853, Gov. Brigham Young sent deputy Rodney Badger (pictured at right) to assist pioneers fording the Weber River. The river was an ice cold, raging torrent and was running deep. One wagon made it across. The next wagon was lighter; it began to float and overturned, spilling the family. Without a thought for his own safety, Badger dove into the dangerous waters, saving the lives of four children and their mother before he drowned.

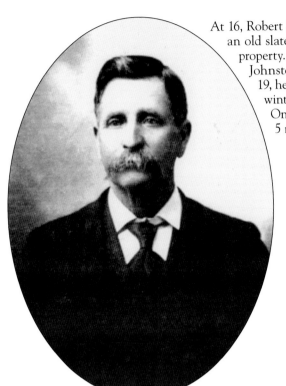

At 16, Robert Lee Bybee traded a cap from Nauvoo for an old slate that he considered a valuable piece of property. He was sent to Echo Canyon to prevent Johnston's Army from entering the valley. At 19, he became a Pony Express rider. During the winters, he was a fiddler for community dances. Once he played for a wedding where he walked 5 miles and earned $3.

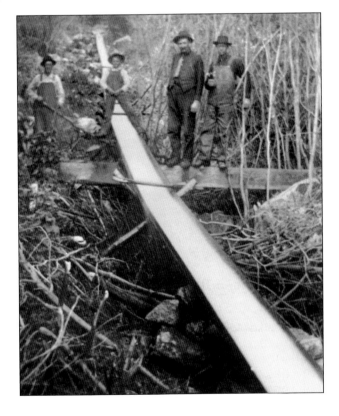

In 1856–1857, River Ditch, now known as Uintah Central Canal, was constructed using a large tree with a prong that was pulled by oxen as it rooted out the dirt. The men used wooden scrappers and hand shovels for the rest of the work. Shown in this picture are, from left to right, Robert Gale, William R. Stoddard Jr., John Dunham, and William R. Stoddard Sr.

In the fall of 1854, the authorities of the Church of Jesus Christ of Latter-day Saints sent word that the activities of the Native Americans were becoming unfriendly. This uprising became known as the Walker War. The people built a fort for protection, measuring about ¼ miles east to west and 500 feet north to south, with walls made of mud. Later, as the community increased in population and strength, the fort was not needed for protection, and the people moved out of the fort.

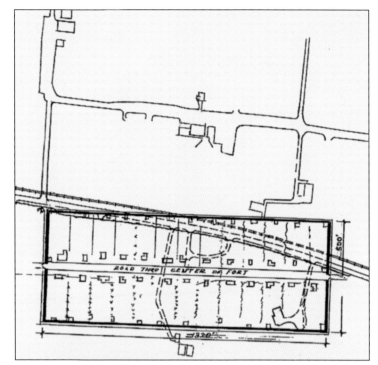

This schoolhouse was built in 1855 with a rock foundation, brown adobe walls, three windows on each side, a door in the north end, and rock slabs on the roof. Books and other school supplies were scarce. The building served the community as a school, a meetinghouse, and a dance hall until 1874. In 1870, Samuel Dye established a circulating library in the schoolhouse.

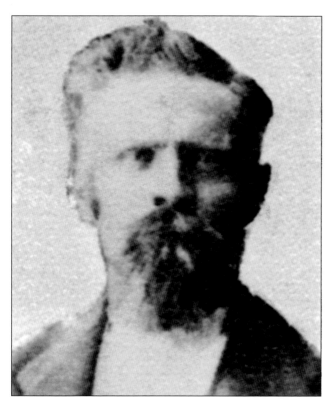

David Bybee operated a toll bridge across the Weber River until it was destroyed by a herd of cattle in 1855. Then he operated a temporary ferry across the river. He was the presiding ecclesiastical officer for the Church of Jesus Christ of Latter-day Saints from 1861 to 1863.

In 1862, East Weber was in the middle of an armed conflict. Joseph Morris was the leader of the Morrisites, an apostate faction that established a settlement in South Weber just across the river. Morris claimed he was the true prophet of the Lord. Successive incorrect prophecies about the Second Coming led followers to become disenchanted and want to leave. A fight ensued, lasting three days, which resulted in the Morrisites' surrender and the death of Morris.

Mary Elizabeth Jones Summers was born during the journey across the plains of Nebraska. Her father drowned in 1865 after he decided to get some float wood from the Weber River. Their first winter alone was very cold. Corn was used for food; her mother shelled the corncobs and burned them for fuel. They all stayed in bed to keep warm and displayed a white flag until help came.

Ira Newton Spaulding served as a justice of the peace. He was appointed the presiding ecclesiastical officer of the Church of Jesus Christ of Latter-day Saints in 1867 and served in that position until he died in December 1882.

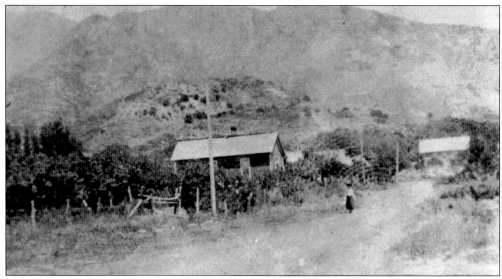

This picture shows what is now known as 6550 South. The eastern part of East Weber was laid out into city lots with streets running at right angles. Every family raised a patch of sugar cane, made homemade molasses, and had a garden.

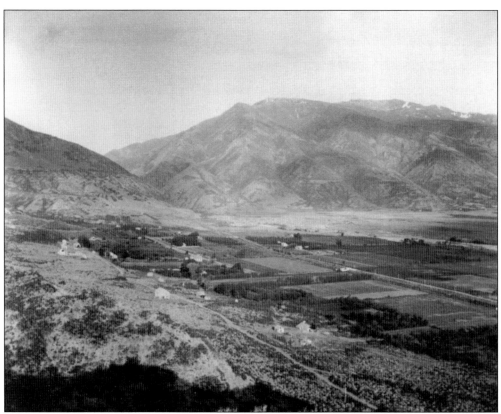

Taken in 1866, this shot of East Weber is one of the earliest in existence. It shows the settlement before development and before the upper railroad track was laid.

18

In 1867 and 1868, surveyors were busy marking the route for the railroad through Weber Canyon into the community. During the winter of 1868–1869, work was pushed so fast that by March the railroad was completed to the settlement. In 1867, the district court ordered that the name East Weber to changed Easton. (Courtesy of Wyoming Division of Cultural Resources.)

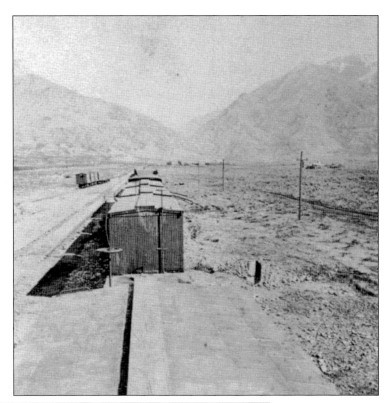

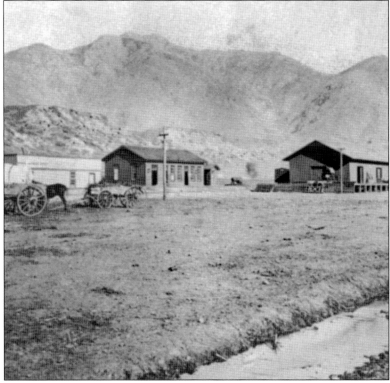

This picture shows the two train stations that existed during this period, one for passengers and the other for the freight office. The railroad stations were called Deseret. From March 1869 until the Utah Central Railroad was completed from Ogden to Salt Lake City, Easton was the terminus for all freight and passenger traffic going south. Easton was named Uintah in 1870.

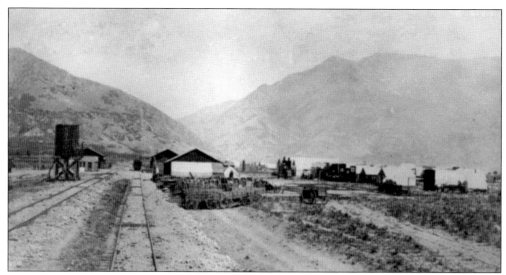

From 1869 to 1872, the community was a real wild and woolly Western frontier town. The population of 20 families in 1866 suddenly increased to about 5,000 residents, which led to the establishment of 25 saloons and 75 grocery, dry goods, candy, and tobacco stores; meat markets; billiard halls; and barbershops. The town also boasted a brewery and a Union Pacific telegraph office.

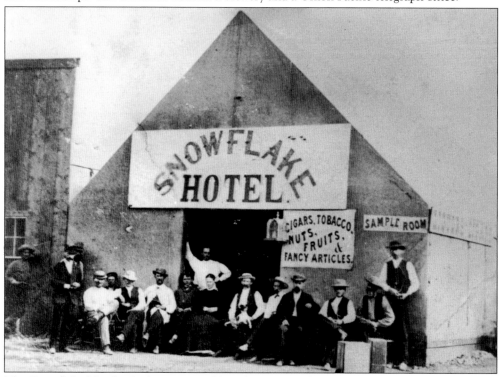

The Snowflake Hotel, which was more like a big tent, with J. H. Colburn as proprietor, stood facing the main street. The street running south was Cedar Street, which had shops on both sides. Pine Street was farther east and not as busy. A brewery stood a little to the west and south. The first Union Pacific telegraph office stood on the north side of the track, where the road to the cemetery is now located.

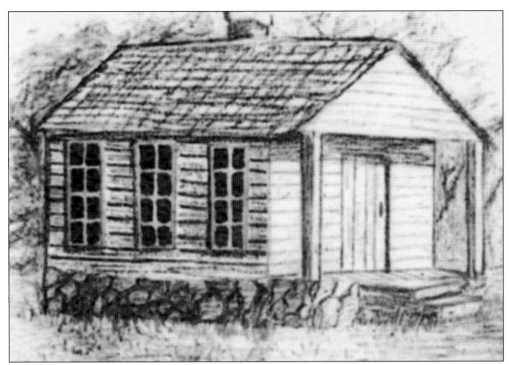

This schoolhouse was used from 1874 to 1891. It was a frame building that was used as a multipurpose building for church and school. It had old wooden desks, chairs, and some handmade benches. Most of the desks had double seats.

Samuel Dye was appointed the presiding ecclesiastical officer for the Church of Jesus Christ of Latter-day Saints (LDS) from 1882 to 1884. In 1866, he organized the first LDS Sunday school and served as superintendent for eight young people. He led all the singing in LDS meetings, along with community singing. In 1870, he established the first library in Uintah.

Alma Keyes, son of William Henry Harrison and Eliza Ann Herrick Keyes, was born in 1839. He came to Utah in 1850 as a pioneer. He was married to Maria Eveline Tracy, who passed away in 1894. He then married Jennie James. He was the chief of the first volunteer fire department in Ogden, Utah. He was a farmer, fruit grower, carpenter, and stockman. He was appointed as the presiding ecclesiastical officer for the Church of Jesus Christ of Latter-day Saints from 1889 to 1917. He held many positions in the Uintah Canning Company.

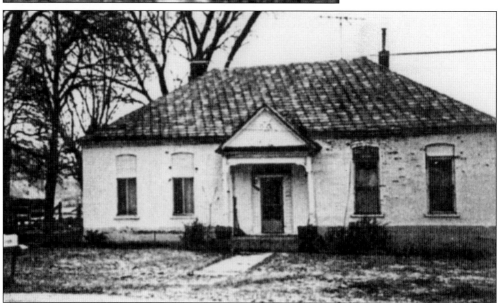

This school was built in 1891 and had two schoolrooms (with a hallway between the two rooms and a door at each end), two cloakrooms, and a library room. The hallway served as a school library and a lockup for unruly kids. A bucket of water and a dipper was near the door for those who needed a drink. The schoolhouse was sold by Weber County in 1899 to Heber Fernelius.

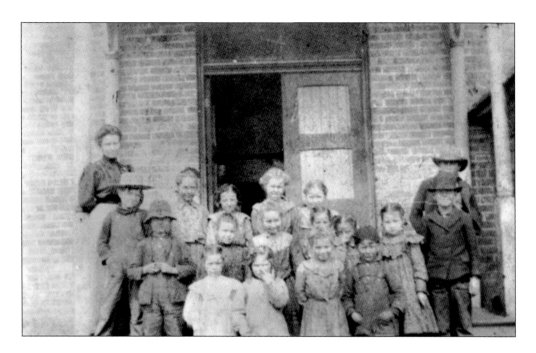

These pictures are the earliest known photographs taken of a class attending school in Easton. The schoolhouse went to eighth grade, with four grades in each room. The picture above depicts the youngest grades, and the one below is of the older grades. Each schoolroom was heated by a large potbellied stove in the center of the room.

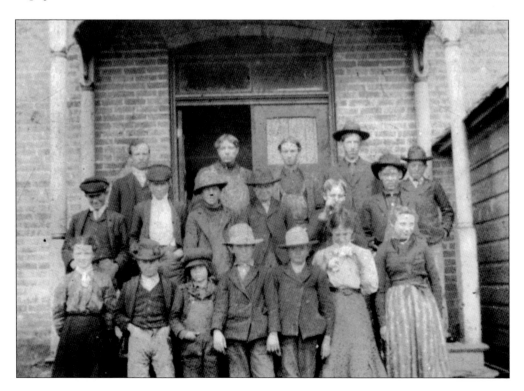

In 1893, a new meetinghouse for the Church of Jesus Christ of Latter-day Saints was erected on land donated by Susan Stuart. The beautiful white-frame church was located north of what is now known as the old Scout Building. A fire destroyed the building in 1957.

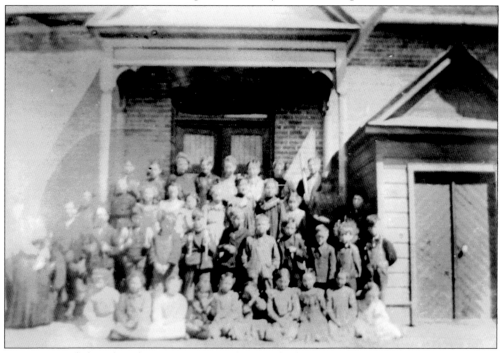

It is estimated that this class picture was taken in the late 1800s. Children from Easton and South Weber attended school together. Those in South Weber walked about 2.5 miles to get to school.

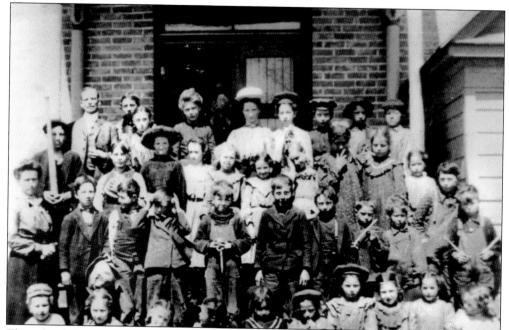

This school class picture shows all of the children that attended school in the late 1800s. Around this period of time, it was not uncommon for children to start school at the age of nine and attend school until eighth grade. Some of the children were needed at home to work on the farm and did not attend school until the ground froze.

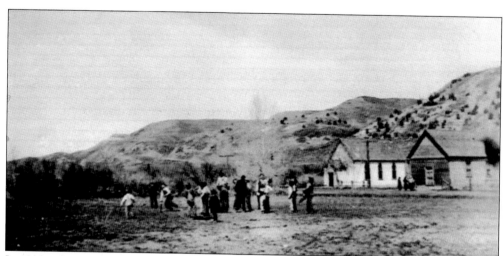

In 1890, a frame social hall was erected at a cost of $650. Whenever the community was giving a dance, Ann Stoddard was asked to cook a midnight supper. Afterward, the dancers would all feast on stewed chicken, mashed potatoes, pickles, and squash pie, which she was noted for making.

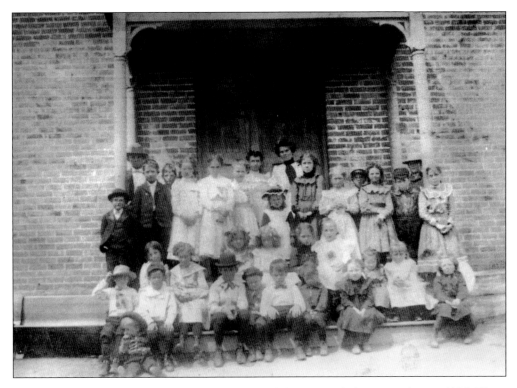

The above picture was taken in the late 1800s, and the picture below was taken in 1896. There were no school activities at that time, but during the daily break, now known as recess, the students played ball, crack the whip, or mumble peg. Walking along the railroad track was a common route since it was mud-free. Placing nails, bottle caps, and so forth on the tracks to have them flattened by the passing trains always provided a great deal of entertainment.

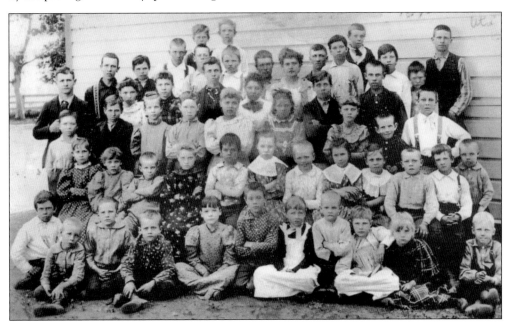

Two

THE MOUNTAINSIDE "U"

During the years from 1919 to
1922, Marlow J. Christensen
was the principal of the
Uintah School (shown in the
background). The school consisted
of a combination of grades: one
teacher having first, second, and
third grades; another teacher
having fourth, fifth, and sixth
grades; and the principal teaching
seventh and eighth grades.

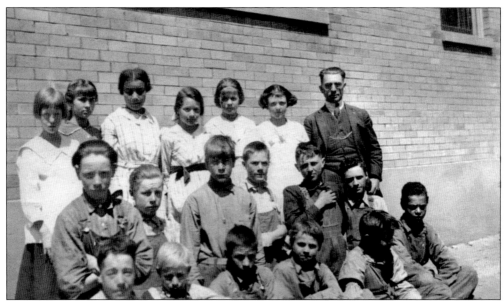

For many years, the Uintah School had only the three teachers, the principal and two female teachers. The students in the seventh and eighth grades consisted of some older, husky boys, as well as others. Six of these larger boys were a real challenge to the principal. They would skip classes and then threaten the teacher if he told or withheld their grades. Their threats became so unreasonable, and their arrogance was so evident, that the principal applied for and received permission to carry a gun for protection.

William Lloyd Bybee, one of the older boys, was courting one of the female teachers, Viola Ahern. Principal Marlow Christensen told Viola that Lloyd was no good and not to have anything to do with him. Viola told Lloyd the story, so Lloyd decided to beat up the principal.

On Sunday night, March 18, 1922, Orville Bybee and several other lads were passing along the road near the Christensen house, making noise, laughing, and yelling. Principal Marlow Christensen came out from his house and approached the boys, and Orville knocked Christensen down. Christensen pulled a gun and ordered the boys to leave, which they did.

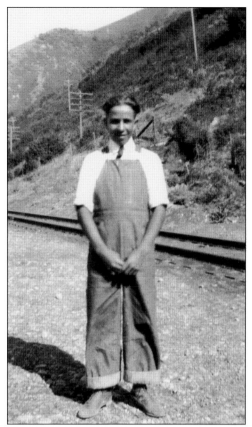

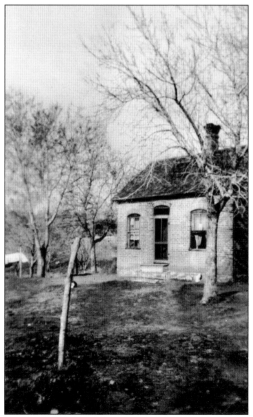

Following the Sunday incident, principal Marlow Christensen expelled Orville Bybee from school for not having his lessons. On Wednesday night, March 22, 1922, Lloyd Bybee, Orville's older brother, hid in the brushes, waiting for Christensen to return home. When Lloyd saw Christensen coming down the road, he moved toward him. Christensen told Lloyd not to come any closer, but Lloyd still advanced. Christensen fired his gun at Lloyd and shot him. Lloyd died shortly afterward, and Christensen was arrested.

The town became divided, some showing support for principal Marlow Christensen, who they believed was compelled to fire the gun in self-defense, and the rest of the town declaring that the shooting was uncalled for. The case against Christensen went to trial on June 29, 1922, in a courtroom filled with spectators. The verdict from the jury was not guilty. A. Golden Kilburn was contracted to teach school in Uintah. He was the 10th principal of the school within six years.

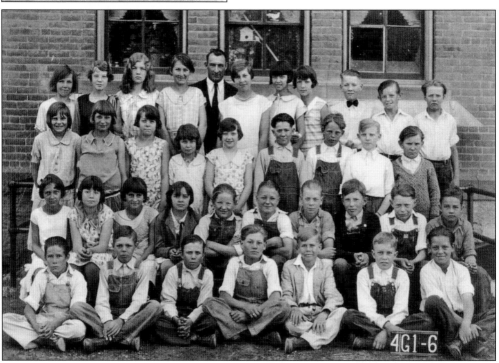

The students, especially the boys of the gang, were hostile to any teacher by this point. They began to throw spitballs and, when asked not to, began to threaten and approach A. Golden Kilburn. He quickly stepped over to the only door in the schoolroom and turned the key, locking the door, and put the key in his pocket. He then faced the surprised class.

A. Golden Kilburn had trained in the navy as a boxer. He looked the class squarely in the eye and said, "All right, if it's a fight you want, fine. I'll take you on one at a time or all of you at once." And he meant it. All but one boy hesitated. He had to be shown and received a good trouncing, which quieted the class. Kilburn then demanded that not one word of tattle or information be given by any student, and if they did, he would find out and then settle with them. He had made his point; all the students returned the next day on time.

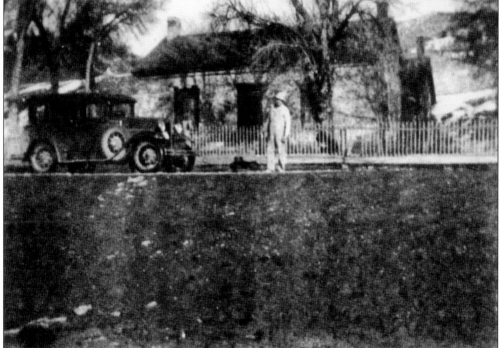

That night A. Golden Kilburn went to his home in Porterville, borrowed his brothers' boxing gloves, and purchased some baseball equipment, basketballs, and hoops. The next day he chose the largest, most rebellious boy (the one he had trounced) to box with him before the class. After that he began to teach the boys how to protect themselves. He organized baseball teams and played with them, teaching them how to be good losers as well as good winners. He often said, "There are no bad boys; we just have to help them expend their tremendous energy in the right directions."

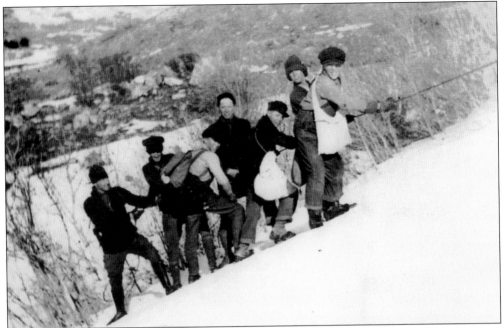

A. Golden Kilburn worked to bring the boys and the town back together to make Uintah united again. The town needed a community project. Kilburn contacted Joseph Orin Bybee and Byram Lee (Bine) Bybee, who each owned a tract of land adjacent to each other on the side of the mountain on the northern flank of Weber Canyon. They agreed that the road and the "U" could be located on their land.

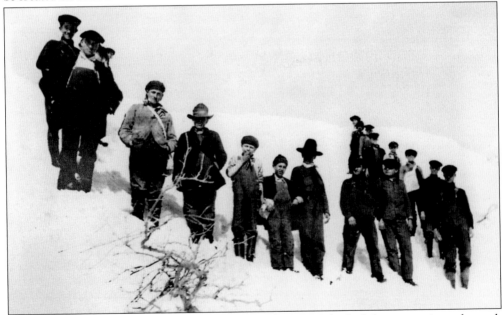

During the winter of 1922, A. Golden Kilburn and the scouts climbed the mountain to the peak above Uintah. The Uintah "U" became a thing of pride to the whole community. Kilburn came up with the idea of putting a "U" on the side of the mountain. To Kilburn the "U" would reunite the citizens of Uintah.

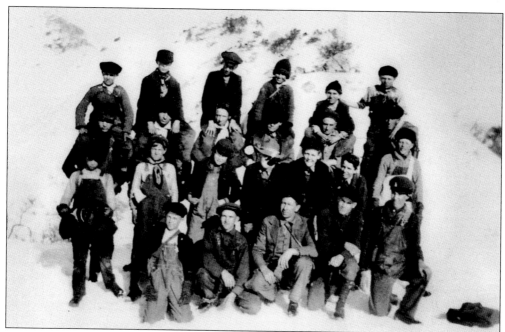

Golden Albert Kilburn got the scouts together and got them interested in building the "U" on the mountain. In the spring of 1923, the scouts headed up the hillside to start working on the "U," which turned out to be a bigger project than they could do. A plea was sent out to the townspeople to help, and they accepted. On April 28, 1923, men, women, and children all joined together so that the "U" could be completed. Nearly everyone in town that could climb the mountain lent a hand.

About this time, the Boy Scouts were being organized throughout Utah. Golden Albert Kilburn talked and worked with his beloved friend and great leader Dilworth S. Young, the scout executive for the Weber Area, and helped organize a local Boy Scout troop.

Elliott Stuart Sr. was appointed as the local Boy Scout leader. He and A. Golden Kilburn spent many hours teaching the boys, gaining their confidence, and showing them how to help themselves. One of the requirements for first-class badges was to participate in a church service, giving talks and leading prayers. When the boys had progressed to this point, Kilburn asked the bishop's permission, and it was arranged for the boys to participate in a Sunday evening meeting.

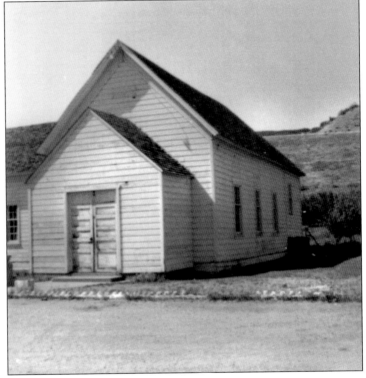

As the parents and folks assembled, it was evident that a definite division still existed when the split congregation sat on opposite sides of the chapel. When the boys gave their talks on "Loving My Neighbor," "Doing a Good Turn Daily," and "Being Trust Worthy," it soon became apparent that the congregation was forgiving. When the boys finished and the meeting dismissed, old friends and neighbors who had been estranged for months crossed the aisle and embraced.

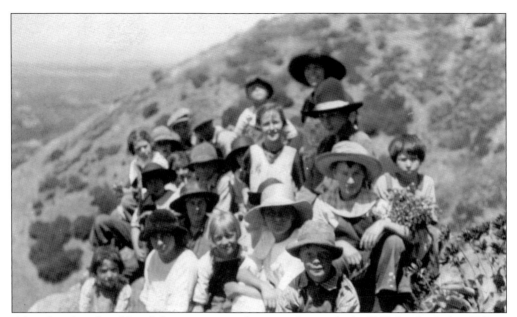

After that day, the old and the young turned out to whitewash the "U" the day before U-Day. Joseph Orin Bybee carried supplies up to the "U" using his horse and wagon. The "U" needed ten 1-gallon cans of water, 6 bags of lime, 10 pounds of salt, and 2 bags of white cement for the whitewash mix. The cement was used so that it would stick to everything, and the salt was used to keep the weeds out of the rocks.

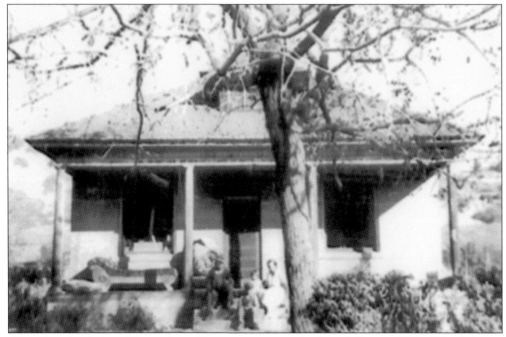

After the school closed down, the celebration was moved to Joseph Orin and May Bybee's home, and it was held there for many, many years. Each family would bring their own food, plus extra, and everyone would share. This affair was usually held in May at the close of the school year.

Nearly 500 citizens participated in the U-Day celebrations on May 14, 1932. At 8:00 in the morning, 200 people climbed the mountain to whitewash the "U." Lunch was served at the schoolhouse at noon, and games and the celebration started after lunch. The PTA was in charge of the U-Day festivities.

The two women in the first row are Ina Bybee (left) and Lola White; those in the second row are unidentified. Sometimes the women would bring decorated box lunches for the men to bid on. The person who brought the lunch was to be kept a secret. If word got out who brought the lunch, and if the crowd knew that the man was sweet on a particular woman, then the men would sometimes bid up the lunch so that it would cost the person more money. Whoever won the bid bought the lunch and the right to eat with that special person. This activity financed the U-Day celebrations for many years.

Pictured from left to right are Ina Bybee, Lillian Stewart, and Lola White. After lunch, everyone took part in sports, foot races, and baseball games in the town. Baseball tournaments were held between different women and men teams.

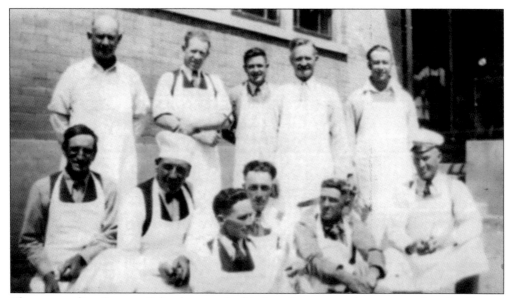

The outstanding feature of the day was the big free dinner served at or near the schoolhouse. The U-Day cooks (shown above) fixed all the food for the 1935 U-Day meal. Pictured from left to right are (first row) Oscar Bybee, George Krauss, Parley Kendell, William Hill, Ray Lamb, and Norman Anderson; (second row) Joseph Orin Bybee, Claude Stanton, George Kendell, Byrum Bybee, and Joseph Dye.

In this picture, taken in the 1940s during the "U" whitewashing, are, from left to right, Rosalie Bybee, Jack Mildon, Wanda Bybee, and Charles Combe.

Alto Stephens is shown mixing whitewash for the "U" while Ben Harvey (second from left) and two other unidentified volunteers are patiently waiting to do the work.

This is a picture of a U-Day float that was a part of the U-Day Parade of 1947.

U-Day king Richard Aeschlimann (far left) and queen Carole Aeschlimann (second from left) are shown with attendants Carlene Dye and Cheryl Hill (far right). They were elected in 1953 to rule over Uintah's homecoming celebration. Events started at sunrise with the whitewashing of the "U" and various activities followed throughout the day.

Gordon Pringle started lighting the "U" in 1955 and continued lighting it until 1990, a total of 44 years. During that period, Gordon was officially in charge of lighting the "U" for 30 years, from 1960 to 1990. To whitewash the "U," volunteers used lime and water. The whitewash was applied with old brooms that people brought with them.

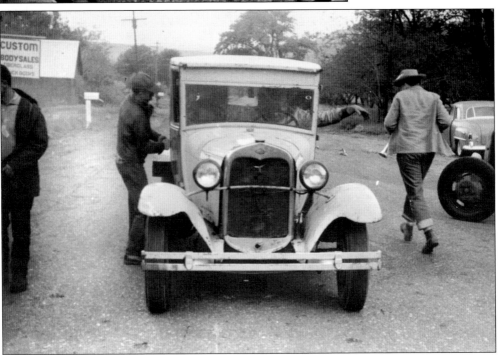

This is a picture of a Model A truck. Driving is Rulon Dye, with Roy Fernelius (left) and Clyde Stoker (right); the old car off to the side belongs to Norman Anderson. At 5:00 a.m. the wake-up call came for those who felt spry enough to help with the "U" whitewashing. Hot-rodders, who had proved their ability as mechanics by making anything on wheels drive through town, used their vehicles to make noise to wake everyone in town.

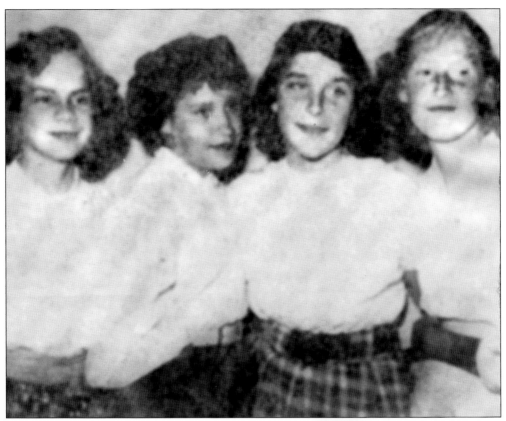

From left to right, Barbara Hill was crowned queen in 1955, with Beverly Fernelius, Sally Aeschlimann, and Linda Jones as her attendants. The events of the day started with the whitewashing of the "U" and then a parade, a band concert, a dinner, games, sport activities, and the lighting of the "U" as the final activity of the day.

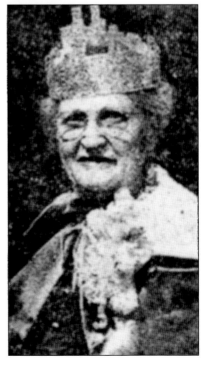

An estimated 400 residents participated in the U-Day activities in 1954. Minnie Kendell was honored and selected as queen of the day's festivities. Alta Peterson and Alma Anderson were selected as her attendants. At the program, it was announced that the founder of the beloved "U" and U-Day, A. Golden Kilburn, had been killed in a traffic accident. The freshly painted "U" was illuminated at nightfall in memory of Kilburn.

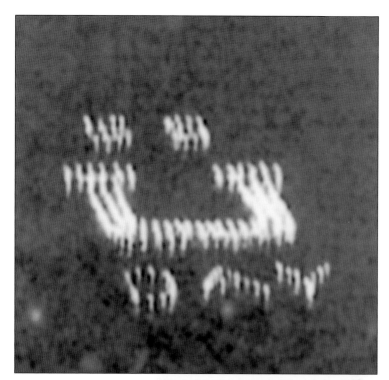

In 1959, the "U" took on a special look, as Gordon Pringle put the year "59" above the "U" and the word "DAY" below. It took all afternoon to put the cans in place for the lighting of the "59 U-Day" that night.

This picture shows Connie Keyes and Norman Anderson painting a miniature of Uintah's giant "U" for the town's celebration. The 1961 activities featured a dance and lighting of the "U" by the scouts. All proceeds from the event went to the Uintah Ward of the Church of Jesus Christ of Latter-day Saints building fund.

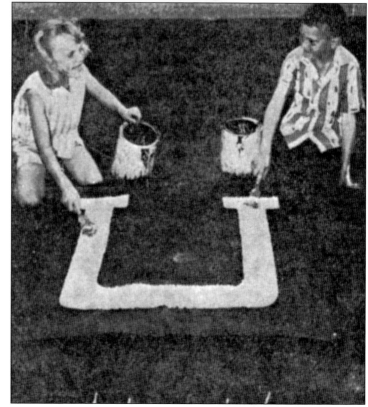

Preparing the whitewash for the 50th annual U-Day celebration in 1973 are, from left to right, Bart Kendell, Yvonne Dye, and Scott Kendell. The celebration was hosted by the Church of Jesus Christ of Latter-day Saints Ward. There were fish scrambles, pony rides, races, baseball, and other events during the day. At night, the "U" was lit to observe the 50th annual celebration.

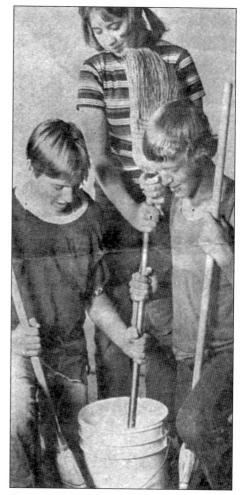

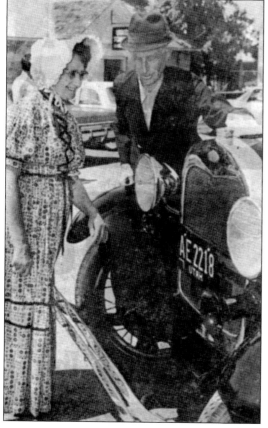

Nellie May and Parley Prophet Kendell were honored at the U-Day celebration in 1970. The Kendells had their 1929 Model A roadster in the U-Day parade. Activities during the day consisted of a baby contest, a parade, sport games, a pie-eating contest, wheelbarrow baseball, a greased-pig contest, and a square dance. In 1970, Elliot Stuart lit the "U" to end the traditional U-Day celebration.

Ruth Doris Jensen Dye, Uintah town clerk, is showing Mayor Dean Fernelius the 1974 Uintah town flag that she created with the design of an old Jupiter-type engine coming through a big "U." The flag was a blue field that featured a large "U" in gold lettering. Also in gold was an early-day locomotive coming through the "U" with the date of 1850. Banners were sold at the U-Day celebrations, and little League jerseys also carried the same design.

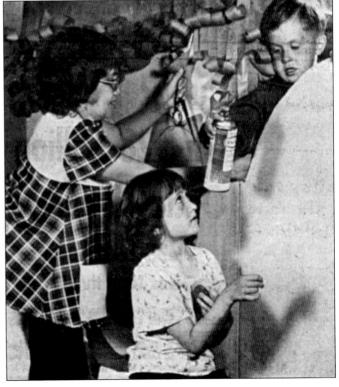

Sprucing up a huge cardboard clown face for the annual U-Day celebration are, from left to right, DeAnn Dye, Hollie Dye, and Kirk Dye. The 1975 event had a parade, a quilt sale, ball games, and, of course, the whitewashing of the "U."

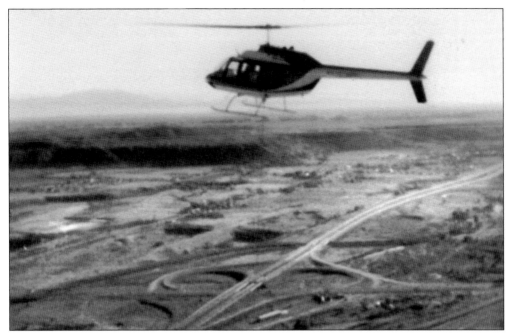

In 1979, under the direction of Gordon Pringle, the "U" was reconstructed. Using the basic measurements from the original "U," stakes were placed in the corners to maintain the shape throughout future years. Strings were tied from stake to stake to outline the measurements of the "U." A helicopter was hired to help in the reconstruction and placement of the rocks.

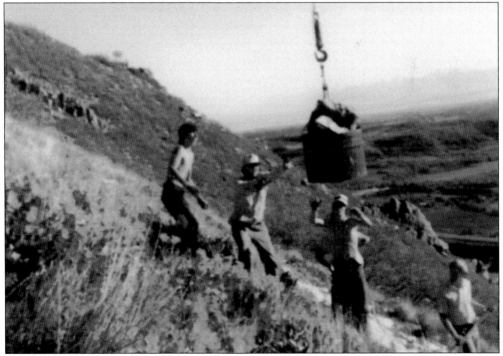

Rocks were placed in the bucket and transported to the hillside, where a crew was waiting to unload them and fill the "U" in the necessary places.

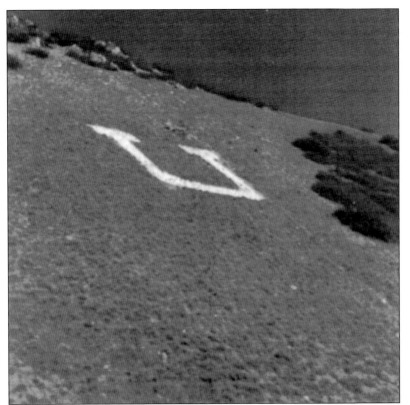

This picture shows the "U" after the construction crew had finished their work. Many hours were spent making repairs.

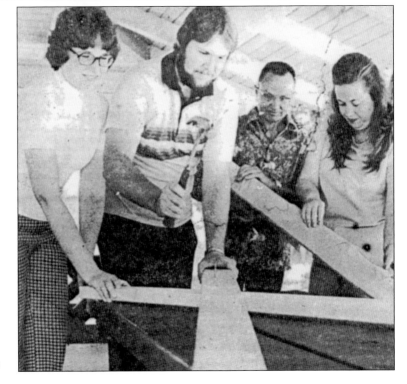

Pictured from left to right are Donna and Dave Boothe, James Fernelius, and Debbie DeGroot working together to build booths for the U-Day celebration. Other activities were old-time fiddler's music, a horseshoe pitching contest, short histories of Uintah scenes, and the treasured lighting of the "U."

U-Day activities took place in June 1980 with the breakfast, flag-raising ceremony, baby contest, parade, sports activities, pie-eating contest, and old-time fiddlers as the events of the day. An auction was held, with the proceeds going to the building fund of the Church of Jesus Christ of Latter-day Saints for a new church.

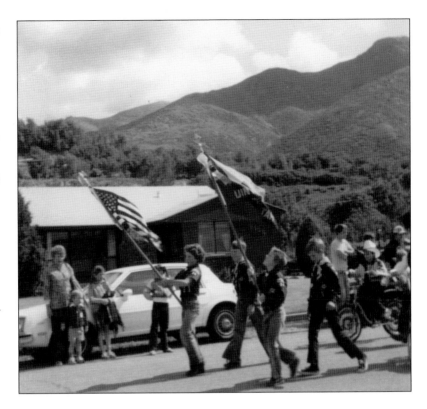

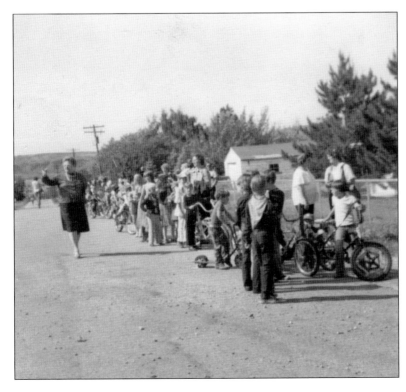

Special ball games, merry-go-round rides, and a greased-pig contest were the highlights of the annual U-Day celebration of 1981. At 7:00 p.m. there was a special community auction of donated items. Concluding the day's activities was a square dance sponsored by the Uintah teens in the park and then the annual lighting of the "U."

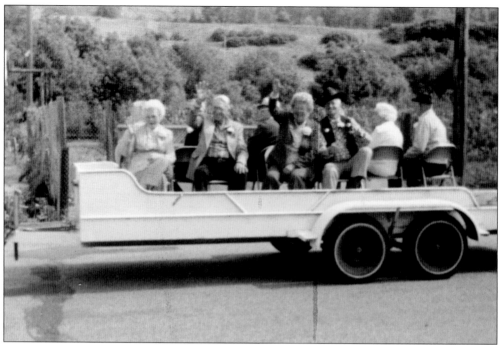

A float carrying the honored citizens was one of the highlights of the U-Day celebration in 1982.

In 2000, for the first time in all the years of whitewashing and lighting the "U," access to the site was blocked. The city took on the task of regaining admittance, and Jim Morkin worked with the current owner of the land, the Utah Division of Wildlife Resources (UDWR). On June 14, 2003, a commemorative signing took place between Craig Kendell, mayor of Uintah City (left), and Kevin Conway, UDWR director. The adjoining landowner, Rich Shock, granted an easement to the city to pass over his property in order to access the "U." At this point, everything was in order for the U-Day celebration and the historic relighting of the "U."

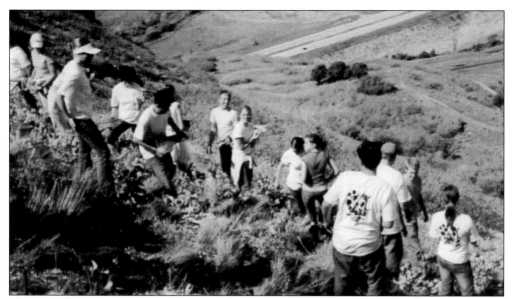

The next adventure was on May 14, 2005, when approximately 258 youth and their leaders from the valley trekked up to the mountain to place the rocks, cover them with wire, and hammer in rebar to hold the wiring. This was quite a job, taking about five hours to complete the whole "U."

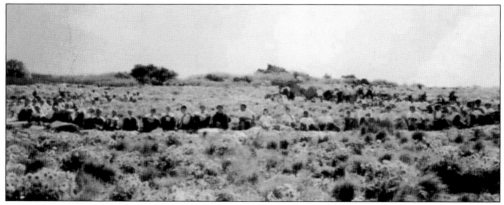

After the work was completed, all the youth volunteers and their leaders formed a line around the perimeter of the "U" that they had been working on.

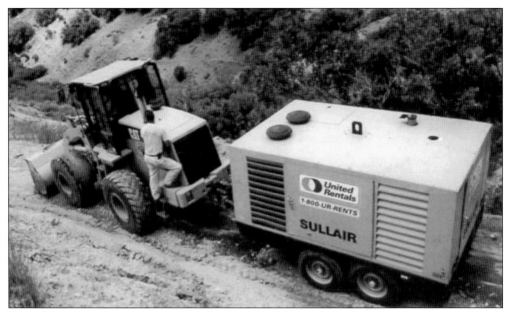

One of the important components of rebuilding the "U" was the high-powered compressor. Butch Barton hauled the compressor up the mountain, which took a complete day to get it up all the hills and turns. As soon as the compressor was at the staging area, the work began to get all the cement and sand up to the staging area and stacked.

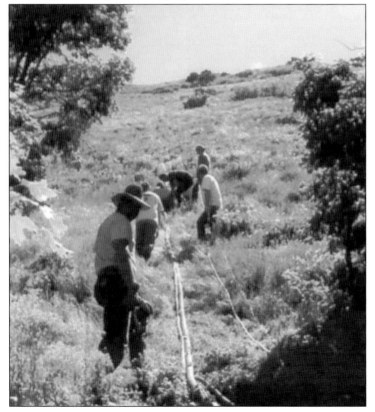

Next, cable was strung through the rocks, and a pulley was hooked up. Ropes were used to pull the hoses up the mountain and to aid the workers as they climbed straight up the hillside. Coming down the mountain using the ropes made for a fast trip that left rope burns, bruises, or cuts if one was not careful.

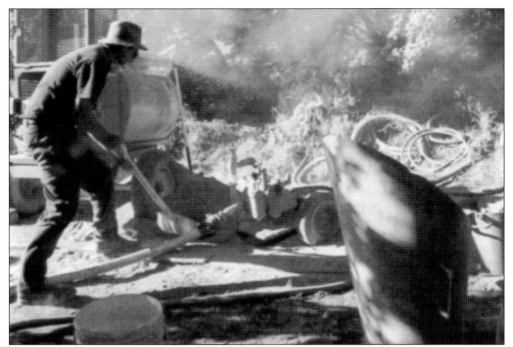

This picture shows Mike Keyes shoveling the cement and sand. The workers took turns between shoveling and working with the hose. The mixture was blown by the high-pressure compressor up the mountain and through the hose, where it was mixed with water at the nozzle and sprayed onto the rocks and wire.

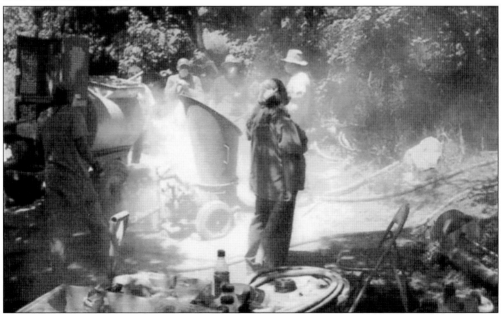

Pictured from left to right are Bart Kendell, Rich Shock, Mike Keyes, and Elanna Luttrell. They mixed the cement and sand before it was blown through the hose. They worked unrelentingly in the hot weather, wearing dust masks and shoveling sand and cement into the hopper that spit and spewed dust everywhere as it mixed the cement and sand.

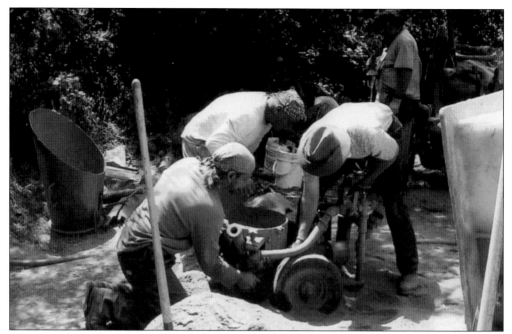

There were several equipment breakdowns. This pictures shows, from left to right, Robert McEwan, Richard McEwan, Bruce Bybee, and Mike Keyes working on the hopper. Whenever a breakdown occurred, those working took the opportunity to rest. The sand was very coarser, which caused the metal to be worn down in the hopper, requiring repairs. Also, the high pressure of the hoses caused them to blow up.

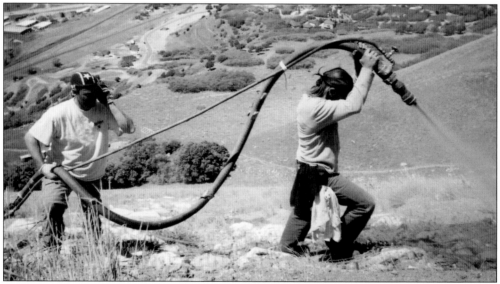

Next came the cementing, which was the heart of the project. It took four days from dawn to dusk, cementing everything that was accomplished before moving on to the final project. Shown in the picture are Robert McEwan (left) and Richard McEwan from Chimney Rock. The spraying of the "U" was quite a challenge, taking about four people to complete; one held the nozzle while others held the hose and supported the back of the one with the nozzle. The third and fourth person had to stand close by, waiting to take their turn in order to help when needed.

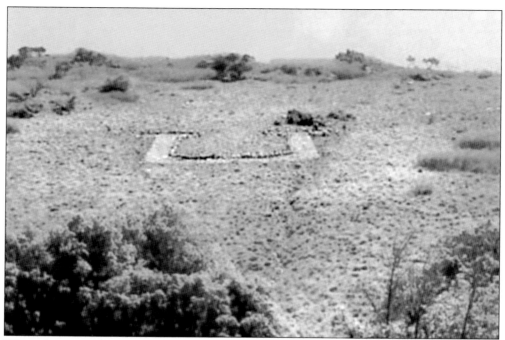

When the spraying was completed, the "U" was gray and seemed to disappear to those in the valley that were watching the process.

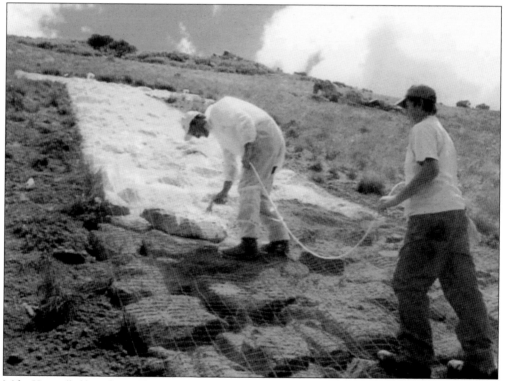

Mike Keyes (left) and Jon Thorsted sprayed the "U" with white paint to bring it back to life again. At this point, everyone who had worked so hard said, "It was worth all that we went through."

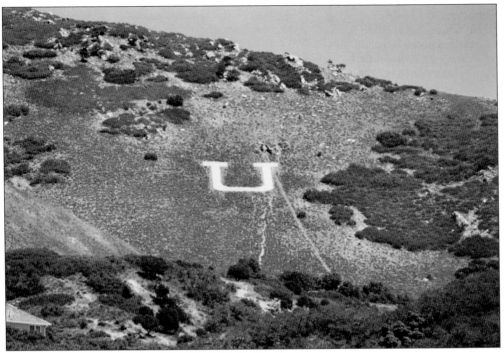

This picture shows the repaired "U" that everyone can see again.

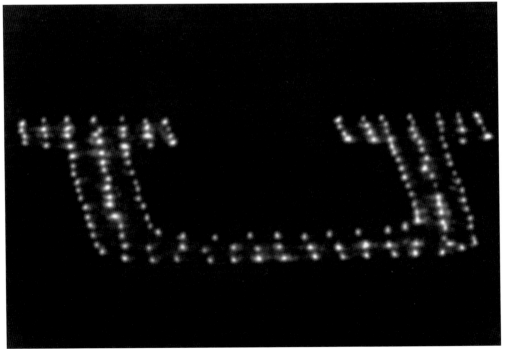

This picture shows the "U" lit before dark. The "U" is now electrically lit for all to see.

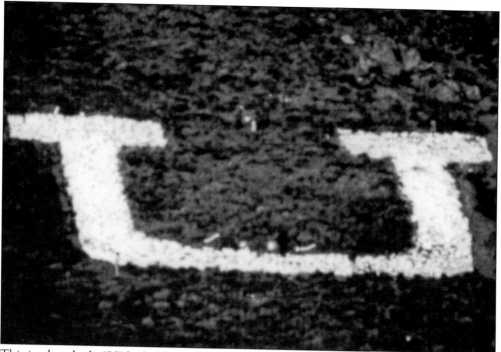

This is what the lit "U" looks like from the valley at night.

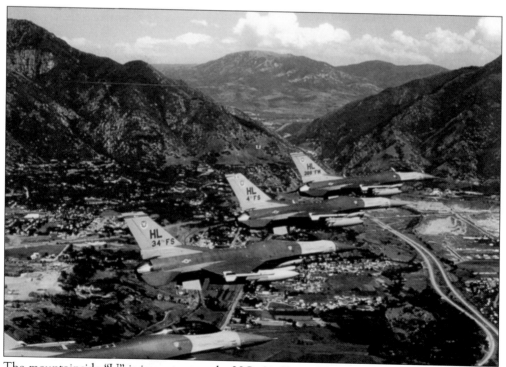

The mountainside "U" is important to the U.S. Air Force. This picture, taken by an air force pilot, shows how the airplanes line up for a landing.

The dinner at the end of the U-Day celebration is now salmon and pork roast with Dutch-oven potatoes, salad, rolls, and dessert. Every year the event gets bigger, with more individuals attending the dinner.

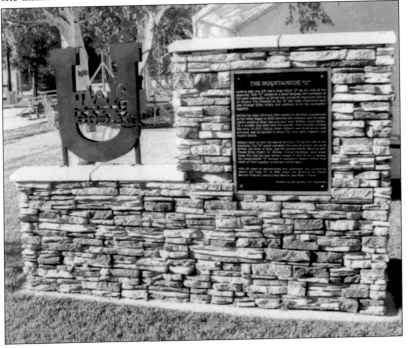

After the "U" was rebuilt, a Mountain "U" sign was placed in the park detailing the reconstruction and those who were involved.

Three

LIFE IN UINTAH

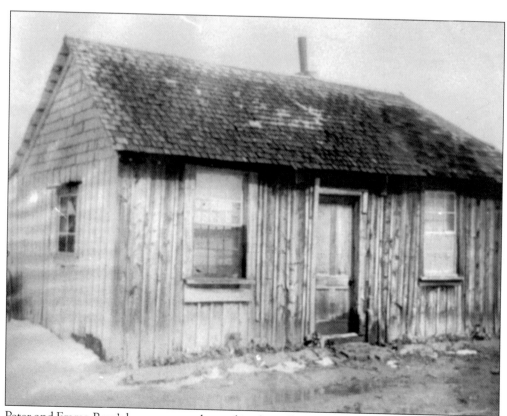

Peter and Emma Borg's home was not located in the valley but on the Uintah Bench (now Borgs Circle), which was part of Uintah in the early days. He owned a considerable tract of land, which he farmed. Peter was well liked by the youth.

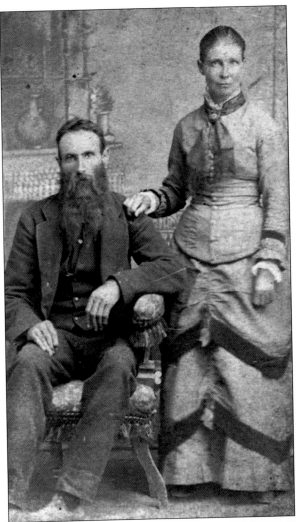

Timothy and Eliza O'Neil settled in East Weber in 1857 and rented until they bought a home. In February 1897, Eliza was honored two days after her 60th birthday with a rocking chair. Eliza had traveled to Utah in 1856 with the Martin Handcart Company late in the year. They were stopped by freezing snow for several days. Many people died from exposure. Eliza and her mother arrived with nothing but the clothes they were wearing. Eliza's mother's legs were frozen, and she was never able to walk again.

Below is a picture of the home of Timothy and Eliza O'Neil that was purchased in 1876 from Ira Spaulding's homestead of 17 acres. When Timothy and Eliza divorced in 1889, Eliza kept the home. She died in 1909, and the home was purchased by Oscar Anderson.

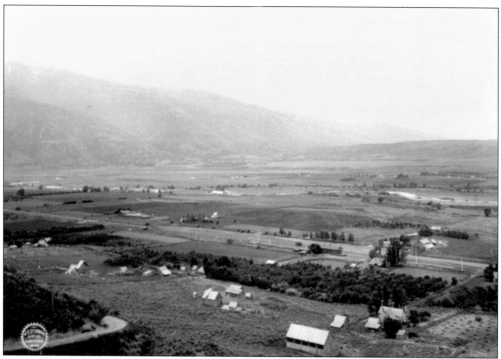

This picture was taken of the valley in 1905. (Courtesy of Wyoming Division of Cultural Resources.)

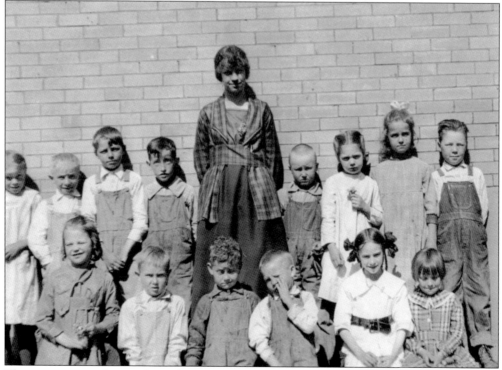

This picture was taken in the early 1900s of the children in the earlier grades.

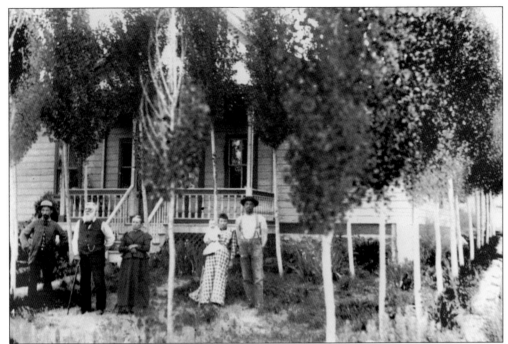

This picture is of the Moses Bryne home. Shown from left to right are Fred Aeschlimann, Catherine and Moses Bryne, Minnie and Fred Kendell, and baby Gretta Kendell. The Brynes moved to Uintah in 1886. The home was located on Combe Road. Previously, when Brynes lived in Piedmont, Wyoming, the Sioux had taken their two-year-old son, who was playing outside a trading post. Bryne asked Chief Washakie to find the boy. In 1871, Chief Washakie brought the boy back, saying he was taken because of his towheaded.

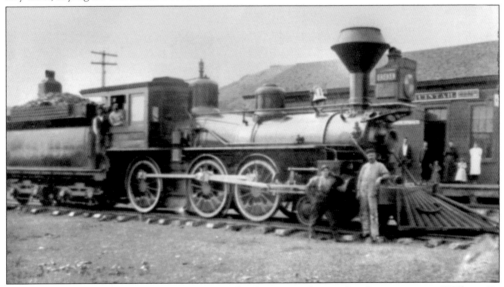

This is a picture of the passenger engine at the first train depot. On the engine are William R. Stoddard (left) and Lepo Krauss; standing by the engine are Tommy Perrins (left) and William Warner; and standing on the porch of the depot are, from left to right, Dan E. Donaldson, Jad Donaldson, unidentified, Eva Donaldson, and two unidentified.

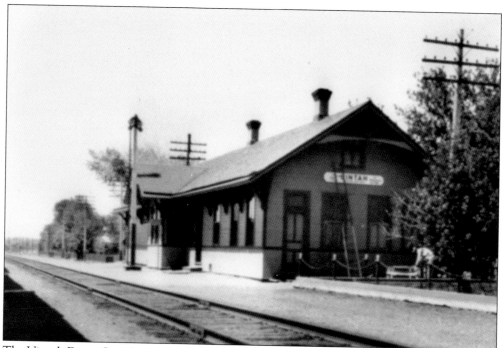

The Uintah Depot Station was divided into four parts. The segment to the east was the residence for the station agent. The area was divided into individual sitting spaces that prevented prone resting if a passenger had a long wait. The passenger section was a large opening with a barricade and counter where one purchased tickets or received mail and telegrams. Located in front of the opening was a large padlocked box in which customers dropped their stamped mail for transfer to the next train. Last was the operation section.

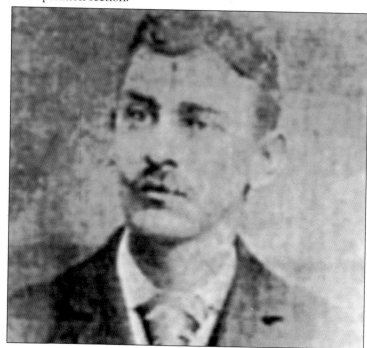

Chief Deputy Sheriff Seymour L. Clark was dispatched to Uintah to take charge of a sick man who had been living in the Kendell barn. The man was concealed behind a stack of shoe boxes at the train depot when observed. The desperado opened fire on Sheriff Clark and shot him. The murderer escaped through the darkness of the night into the land near the river. The search continued for several months; however, the desperado was never apprehended.

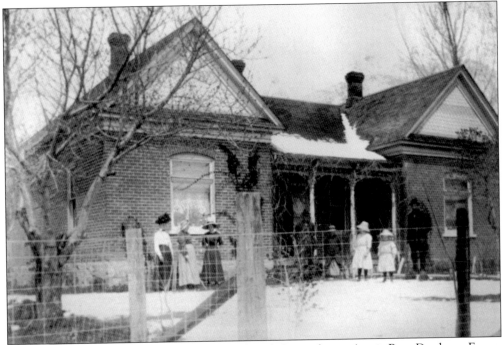

The Stoddard home was built in 1910. Shown from left to right are Annie Borg Dunham, Emma Borg Stoddard, Myrtle Bishoff (school teacher), William R. Stoddard Sr., Will R. Stoddard Jr., Elva Stoddard Dye, Sarah Dye, and an unidentified man.

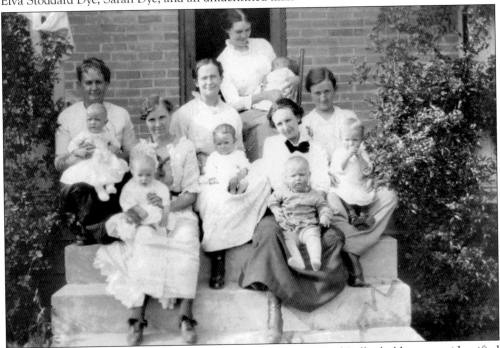

Six babies were born in June 1914. Shown from left to right are Enid Rollin holding an unidentified baby, Emma Lucine Jaques holding Ireta, Laura May Fernelius holding Merle, Zina Peal Rollins holding Theron, Mary Lucetta Bybee holding Lane, and May Lawson Bybee holding Grant.

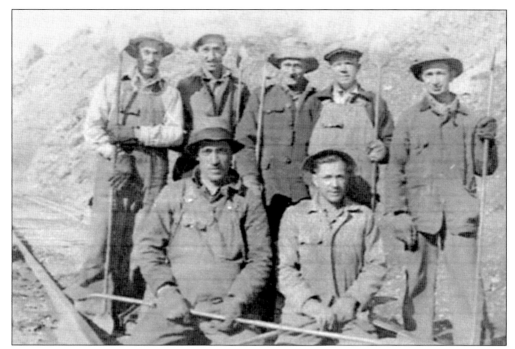

Uintah was the home of many railroad workers. Shown from left to right are (first row) William Hill and Albert Kendell; (second row) John Pringle, Melvin Bybee, Gilbert Fernelius, James Fernelius, and Timothy Kendell.

This is a picture of Elmo Louis Hamre. The Hamre home was located on the hill above Highway 89. He was one of the first scouts who went up the hillside to build the "U." In the late 1920s, Loris and Elmo Hamre installed a pipe with wire supports above the "U," which became a flagpole. Each morning before the whitewashing began, the flag was raised. Several years later, the flagpole fell down and was not replaced.

Henry Berghout built the Dye home in 1930–1931 for $3,400. The basement was dug and formed, and Jonathan Samuel Dye and his brothers poured the cement. The family moved into the home in the spring of 1931. Rulon Dye was born in the home on May 7, 1931. The home had one of the first water systems in Uintah. After Jonathan's death, his son, Neil Dye, moved into the home.

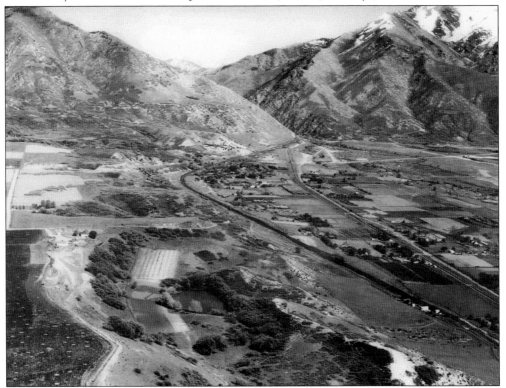

This aerial view of Uintah was taken in the late 1920s or early 1930s.

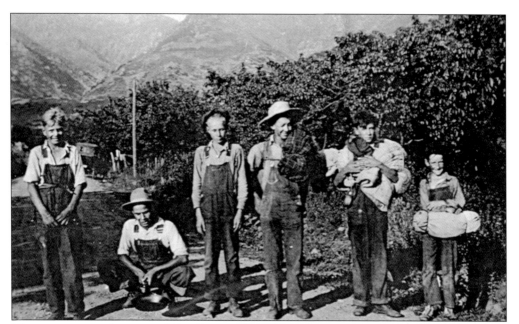

This is a picture of a group of Boy Scouts who were going on a camping trip. Melvin Bybee is standing on the far right; the others are unidentified.

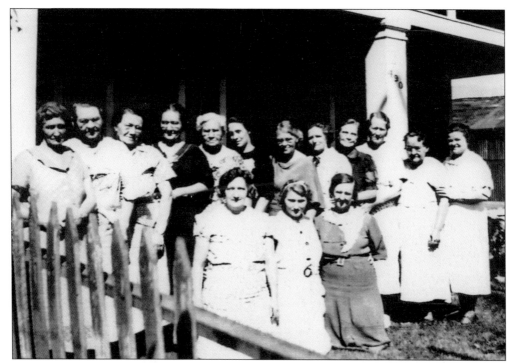

In the late 1920s, the women in Uintah formed a group called the Happy Birthday Club. They met monthly at someone's home, had lunch, quilted, and played Bunko. They were a close-knit group of women from the area and continued meeting together into the 1950s.

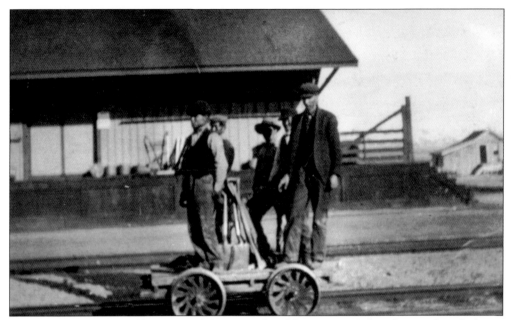

Lewis Bernhardt Hamre (first row, right) was a railroad foreman, and the other unidentified men were section hands. They worked for the Southern Pacific Railroad and the Union Pacific-Oregon Shortline Railroad. Hamre, as well as many other railroad workers, lived in the railroad housing that was located by 1725 East.

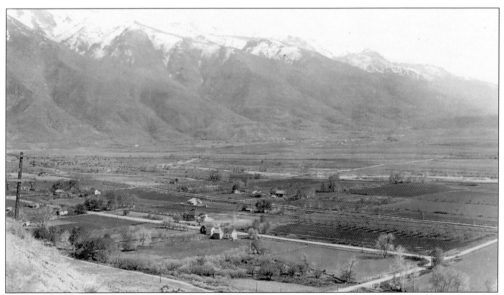

This picture of Uintah was taken from the Dugway in April 1930.

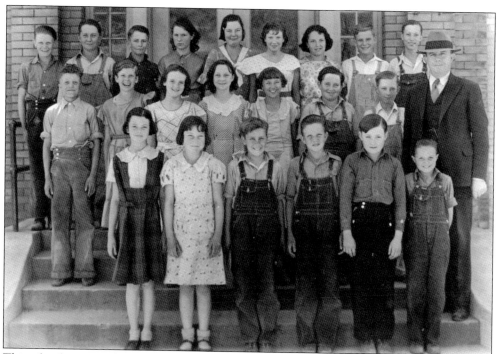

This school picture of the sixth grade was taken in 1934.

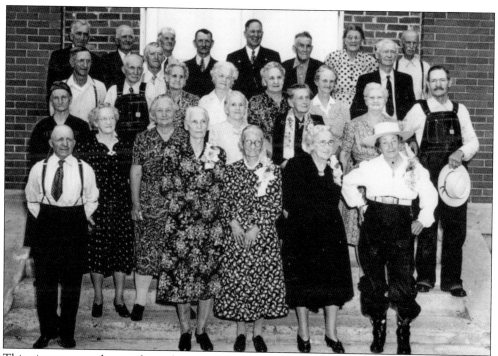

This picture was taken at the gathering of the Uintah Old Folk's Day in 1940.

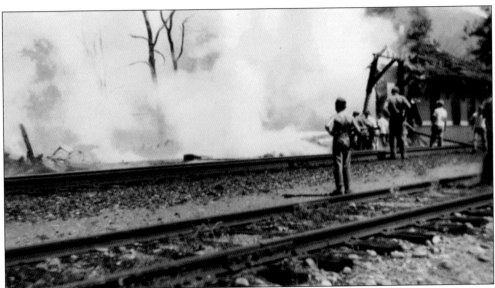

The station, built in 1906, was destroyed by fire on August 26, 1946. The loss of the station was estimated to exceed $7,000. Members of Weber County Fire Department and railroad crews battled the fire for five hours. Approximately half of the frame structure and most of the roof were in flames when firemen arrived. Residents removed furniture and household goods in an effort to save what they could. Stationmaster D. E. Donaldson was living at the station at the time and had been the station agent since 1888.

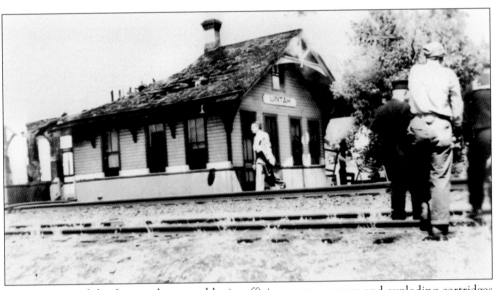

Containment of the fire was hampered by insufficient water sources and exploding cartridges from a case that was stored in an upstairs room. The firefighting crew was forced to rely on the small storage of water carried in one of two trucks taken to the scene and a hydrant containing only enough pressure to keep the water pipes filled. Irrigation water was also turned down a nearby ditch to help in the efforts to save the structure. While fighting the blaze, it was necessary for the firefighters to remove their hose from the tracks several times to allow train service to continue.

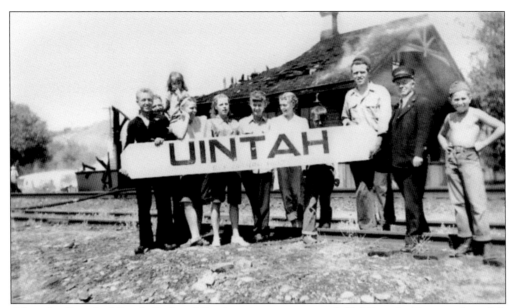

After the fire, the Uintah Railroad Station sign was removed. Holding the sign are, from left to right, Bert Kendell, James Fernelius, Joan Stoker, Joanne Stuart, Alice Fernelius, Afton Anderson, Marguerite Stoker, Allen Kendell, Kenneth Stuart, Max Kendell (conductor), and Albert Aeschlimann.

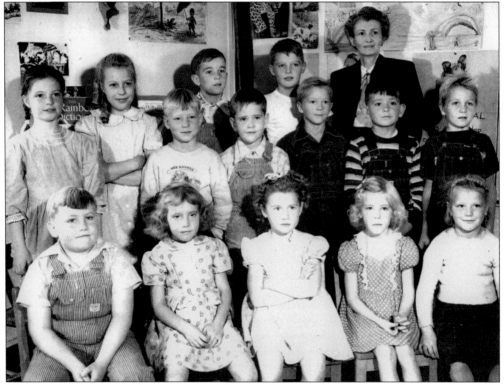

This is a school picture of first, second, and third grades, taken during the school year of 1946–1947. The teacher was Inez Bowman (third row, far right).

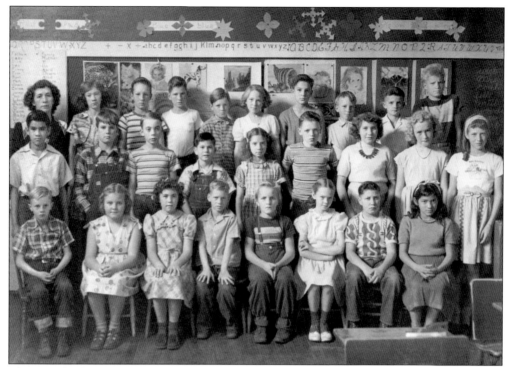

This is a school picture of the second-grade class during the school year of 1948–1949. The teacher was Inez Bowman (third row, far left).

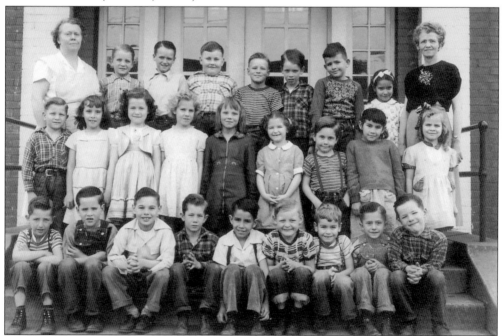

This is a school picture of fourth, fifth, and sixth grades during the school year of 1948–1949. The teacher was Maude Mildon (third row, far right), and the cook was Sara Dye (third row, far left).

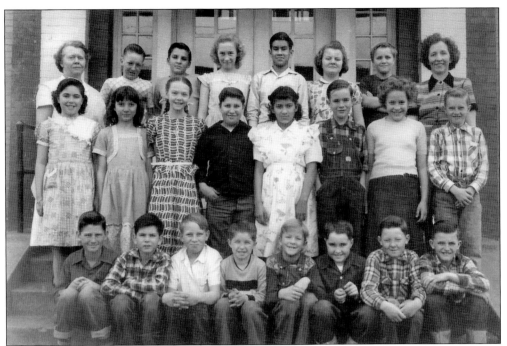

This is a school picture of fourth, fifth, and sixth grades during the school year of 1949–1950. The teacher was Inez Bowman (third row, far right), and the cook was Sara Dye (third row, far left).

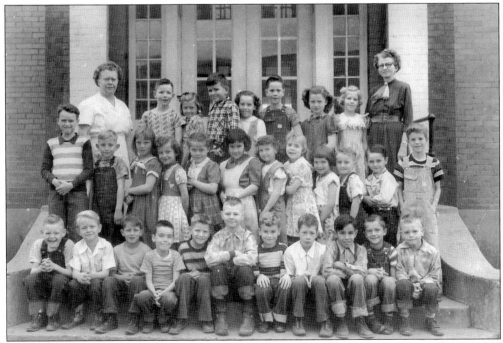

This is a school picture of first, second, and third grades taken during the school year of 1950–1951. The teacher was Inez Bowman (third row, far right), and the cook was Sara Dye (third row, far left).

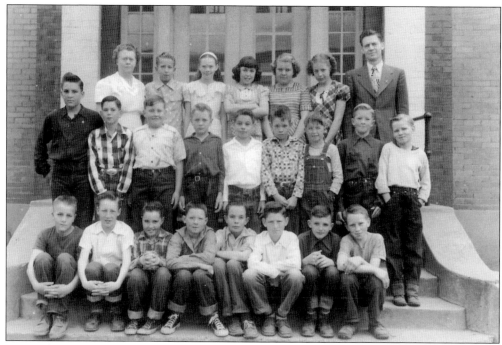

This is a school picture of fourth, fifth, and sixth grades during the school year 1950–1951. The teacher was Russell Cornelius (third row, far right), and the cook was Sara Dye (third row, far left).

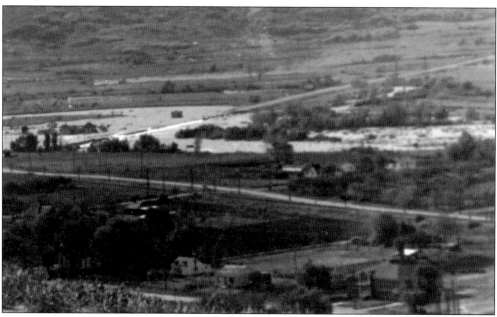

In May 1952, the Weber River broke from its banks west of the mouth of Weber Canyon. The force of the river flooded across Highway 89, tearing out the roadway. The water tore a steel bridge loose that was located on 2275 East, which had long been a connection with South Weber. The water swung the bridge around parallel with the raging river, making it a total loss. It was hauled away, never to be replaced again.

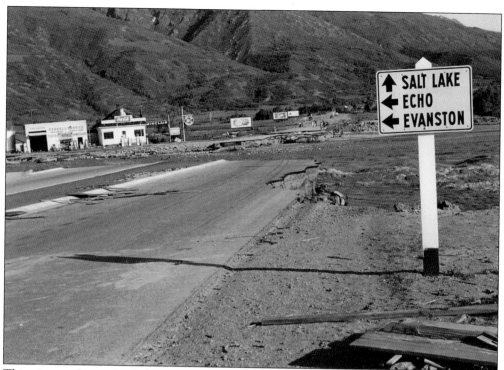

This picture shows the flood damage that was in front of the Kendell Store, located east of Highway 89.

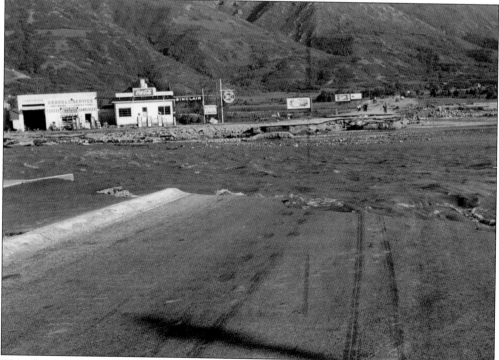

This photograph shows the section of Highway 89 that was washed out.

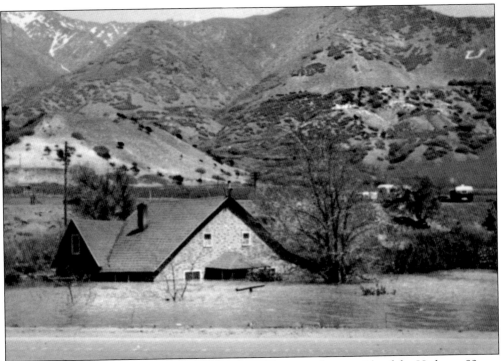

The two-story home of Jesse Essrum and Russletta Sharp on the east side of the Highway 89 was flooded up to the eaves. The Sharps moved into a tent and trailer located on high ground in the back of the house until the floodwater receded. They lost most of their belongings to the flood.

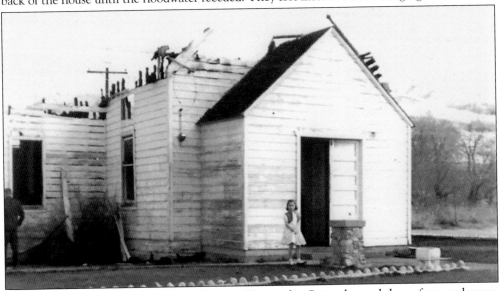

In March 1957, the Church of Jesus Christ of Latter-day Saints burned down from unknown causes. The structure was the social center of Uintah. Smoke was first seen around the chimney by a Union Pacific Railroad worker, Arthur Combe, and his son, Basil. The Combes, along with Claude Stuart, attempted to turn a hose on the structure to save it. The organ, chairs, and other movable furnishings were removed from the building. The building was practically destroyed before the fire trucks arrived.

The Uintah Boy Scouts, through fund-raising efforts in 1958, built their own scout house west of the school area under the leadership of scout master George Garner. Many individuals spent long hours constructing the building for use by the scouts. The building was in demand by other groups for social events and classroom space for the Uintah Ward of the Church of Jesus Christ of Latter-day Saints. Rental money from these events helped to pay off the building costs.

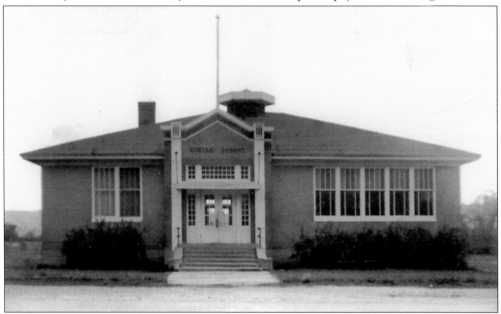

This Uintah School was built in 1957 and was the last school to be constructed in Uintah. It had two classrooms in which six grades were taught, a cloak hall, and a recreation hall with a stage, which later became a lunchroom where Sarah Dye and Elizabeth Fernelius served as cooks. The school was demolished in 1960 to make way for the town park.

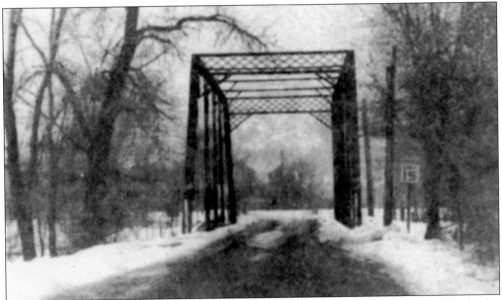

The bridge was moved from Riverdale in the fall of 1925. In 1977, a truck fell through the bridge into the river, bending one of the steel beams. After the accident, a 6,000-pound limit was placed on the bridge. In March 1986, construction of a replacement bridge was started after a three-year effort to get approval to remove the bridge that was over 100 years old.

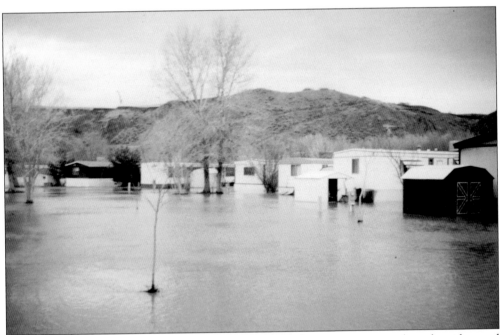

In February 1986, heavy rain along with high snowpacks and warm temperatures brought widespread flooding throughout Weber County and along the Weber River. The dike located along the Weber River in Uintah eroded away and flooded several homes in the area. This picture shows the flooding in the Cottonwood Mobile Home Park.

Shown on the right of this picture is the dike that eroded away, bringing the force of the Weber River into this home. The home was completely surrounded by water. The force of the water washed out the road, filled the riverbed with gravel and debris, cut flood channels through flood land, and filled up the area east to Highway 89. Weber County rebuilt the dike in order to stop the flow of water into the home and to help contain the water.

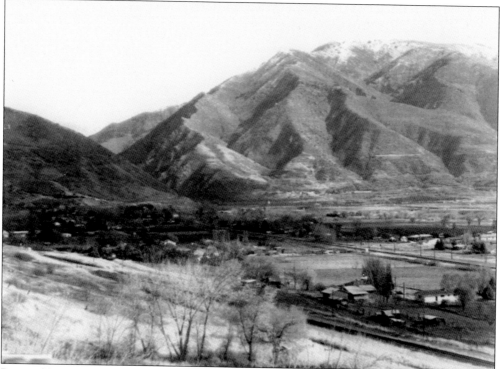

Pictured here is an overview of Uintah in 1989.

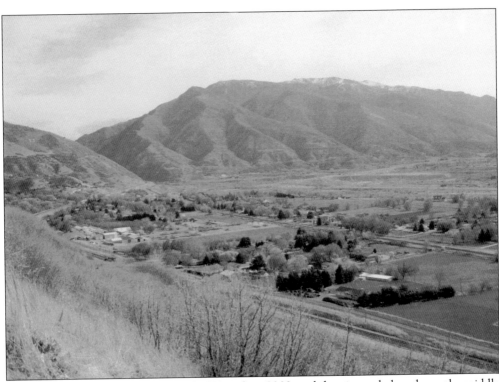

The above picture shows the east end of Uintah in 2009, and the picture below shows the middle to west end of Uintah. Uintah has grown to around 1,400 people with 400 homes.

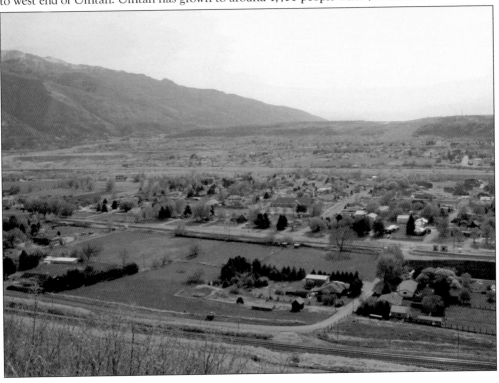

Four

HALL OF FAME

Alma Milton Anderson was born in 1909 and was raised in Uintah. His parents were Anders and Alma Mathilde Johnanson Anderson. He was a mild-mannered person and was well liked by everyone. As a young man, he worked for Jonathan Samuel Dye on a threshing machine at different farms throughout the area. He married Alva Eliza Hunsaker. He was appointed the presiding ecclesiastical officer for the Church of Jesus Christ of Latter-day Saints from 1953 to 1962. During his tenure as bishop, he spoke at more funerals than any other bishop. He served as mayor of Uintah from 1966 to 1970.

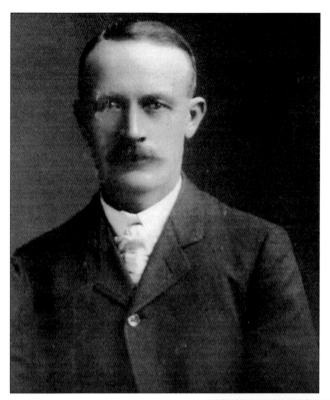

Andrew Anderson worked in tie camps making railroad ties for the Union Pacific Railroad and then became a supervisor for the railroad. At this time, he was married to Josephine Juditta Nilsen, who died in 1906. In 1908, he married Alma Mathilde Johanson and quit the railroad. He then purchased some land in Uintah to build a home for his family. Andrew and some of the other farmers in town who shipped their produce got together to form a co-op and to build the Uintah Canning Company. He took the lead in securing electricity for the town. He said many times, "I don't expect to get much good out of it, but somebody will." He died the day his son, Norman Anderson, finished wiring his home and turned the lights on.

Josephine Juditta Nilsen Anderson came to the United States around the age of 16, when Andrew Anderson sent for her to come and marry him. Andrew's brother had been on a mission in Norway and sent Andrew a picture of Josephine. He thought that she would be a good wife, so he sent for her. Josephine's first love was to do something good for somebody. One of her neighbors, the Gale family, lost their home by fire. Before the fire had fully died down, she sent word to them to please come down and live with them as long as necessary until they could get located again. Josephine spent many hours supporting her husband in his businesses. Her parents were Hans Carinius and Kirstine Mathiasdatter Nilsen.

Norman Harry Anderson was a kind man, and when he was young, he loved to play jokes on people. His parents were Andrew and Alma Mathilde Johanson Anderson, and he married Gretta Izora Kendell. They always welcomed everyone into their home. He was the custodian at the Uintah School, where he kept the wood floors well oiled and the desks neatly placed in rows. He was a good artist, and he loved to share his talent with the kids. He would always draw pictures of pumpkins, turkeys, rabbits, and Santa Claus on the chalkboards for each holiday.

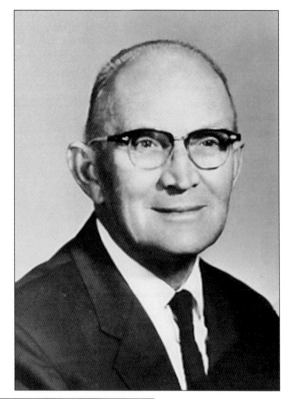

Oscar and Mekka Regina Rosenvinge Anderson were from Peterson, Utah, and moved to Uintah in 1922. They had a little white house that was set about 150 feet back from the road at 2200 East. It has been said that their home had been the old Wells Fargo place before it was remodeled. Oscar had thick glasses. He was a stern person, but he was friendly. His wife, Regina, had a strong Swedish accent when she talked. They had a small farm with a few milk cows.

Wendell Kendell Anderson was born in 1930. His parents were Norman Harry Anderson and Gretta Izora Kendell. He was afflicted with the dreaded disease of polio at the age of 16. Before he got sick, he worked hard on a merit program for the youth. He earned the privilege of going on a trip into the mountains, all expenses paid, along with 25 other young men. He thoroughly enjoyed the trip; it was such an adventure for him. Shortly after his return, he got polio and was placed in an iron lung. He remained in the iron lung for nine months, at which point he was able to return home, with some trips back to the hospital. Kendell's greatest desire was to create an organization of young men who would help others (known as the JCs) in Uintah. However, Kendell passed away in 1958 before the organization was finalized. After his death, the organization was never completely established.

Eldon Mathew Bechel was born in 1929 in Wisconsin to Joseph and Anna Schmit Bechel. After he retired, he and his wife, Janice A. Schultz Bechel, moved to Uintah. He served on the city council from 1992 to 1994 and as Uintah's mayor from 1994 to 1998. Eldon passed away in 2006 in an automobile accident in Nebraska.

Beverly Jean Bohman Bingham became the Uintah town recorder when Ruth Dye retired in 1982. Beverly was recorder until 1988, at which time Sherma Mildon replaced her. During the period that Beverly was recorder, all work was done from her home. She was also the court clerk from 1985 to 1987. Beverly was married to Gordon Pringle (now divorced) when she was the town recorder. She is now married to Grant Bingham. Her parents were Charles Alfred and Josephine Mary Carrigan Bohman.

Byram Levi Bybee had a small stature, blue eyes, and a sandy-colored mustache and beard. He had a beautiful tenor voice and played the violin for dances in the early days. He married Jane Geneva Robinson Bybee. In the late 1860s and early 1870s, Byram Levi used his expert marksmanship to supply the Union Pacific Railroad camps with deer and bear meat, along with pine hens. He was the road supervisor for the Uintah Precinct and supervised the building of the first Uintah Dugway, which was built in 1898. It was not unusual for the Native Americans to come to his home for food.

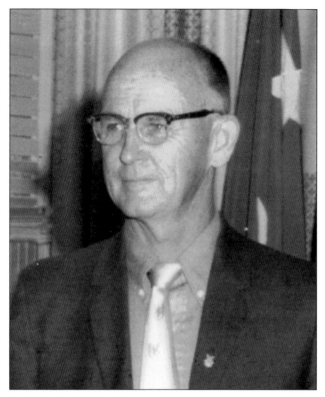

Grant Bybee was born at home in 1913 to Joseph Orin and May Lawson Grix Bybee. He lived during the time when there was no electricity or plumbing in the home. As of 2010, he is the only surviving person of the original group that built the "U" on the mountainside. He enjoyed going fishing and hunting with his father and all the Bybee relatives. He participated in the dances at the old recreation hall by the church house. He grew up working on the family farm and for neighbors to earn extra money. He was appointed the assistant scoutmaster in 1931. Grant is also remembered as the person who came up with the idea and the plans to build the Boy Scout building. He was married to Mary Ellen Taylor, who died in 1986. He is now married to Lucille Willard Loftus.

Jane Geneva Robinson Bybee was born in Nebraska in a covered wagon in 1848. She came to Uintah in 1867, when she married Byram Levi Bybee. She was a stern person but cared deeply about her family. Jane was an expert seamstress, made all her own candles, and sold butter for 15 or 20¢ a pound to supplement the family's income. She was a very good cook and cooked dinners for community dances. She boarded schoolteachers in her home for the Uintah School. When their home was bought by the Union Pacific Railroad in 1911 and their new house was built, she insisted that no plumbing facilities would be added to the home.

John McCann Bybee was born in 1829 in Kentucky to Byram Lee and Elizabeth Ann Layne Bybee. He was known for his humor and wit, always having a joke or a story to tell. John married Mary Polly Smith. John dug the graves for many of deceased individuals. This was not an easy task with only the use of shovels, especially when considering the large amount of rocks in Uintah. John is the only person buried in the Uintah Cemetery who fought in the Mexican War.

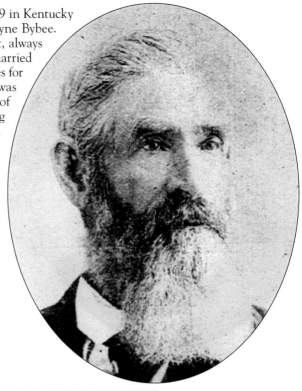

Joseph Orin Bybee was born 1883 to Byram Levi and Jane Geneva Robinson Bybee. He loved to hunt more than any other person in Uintah. Orin married May Lawson Grix. He would take all his boys, relatives, and friends on hunting trips where they would set up a large camp and hunt for weeks. When he was 15 years old, he was working 10 hours a day on the first Dugway. Orin was a part-time farmer and had several cows in a barn by the upper railroad track and 30 to 40 acres down by the river. He was deputy assessor for the Uintah Precinct for 16 years.

Robert Melvin Bybee, son of Robert Oscar and Mary Elizabeth Goodwin Bybee, was born in 1912. He was elected the mayor of Uintah in the 1949 elections. He was disqualified due to the fact he was not a resident of Uintah, as he was living at the power plant that was outside the boundary. At age 61, he was the oldest known softball player in Utah and could have been the oldest active player in the nation. He was first introduced to the sport in elementary school and continued through the years, playing for Weber High School. He played on the Utah Power and Light League and with his church league. His son, Neil Bybee, has also played on the same team as his old man for several seasons.

May Lawson Grix Bybee was a daughter of Lamoni and Sarah Greenway Lawson Grix. She became a qualified schoolteacher and arrived in Uintah in 1910 to teach first, second, third, and fourth grades. She boarded with Jane Geneva Robinson Bybee, where she met Jane's son, Joseph Orin, and later married him. In her later years, she was a substitute teacher. May was a slender person who was pleasant and polite. Most of the kids in town would call her "Aunt May" to show their respect and love for her. May always liked to give her friends a hug and a kiss when greeting them.

This picture shows Luke Mildon (left) and Fire Chief Neil Bybee with the addition of a new hose on the original fire department brush truck. The Uintah Volunteer Fire Department was established in 1970 in an effort to provide quicker service. It was officially chartered in January 1972. The department has been served by numerous community volunteers and 10 volunteer fire chiefs: Neil Bybee (1971–1976), Luke Mildon (1976–1977), Luther Sutherland (1977–1978), Lenard Kendell (1978–1980), Kirk Combe (1980), Robert "Bob" Amundson (1980–1986), Scott Alvey (1986–1997), Jack Lucero (1997–1998), Mike Marz (1998–1999), and Dave Boothe (1999–present).

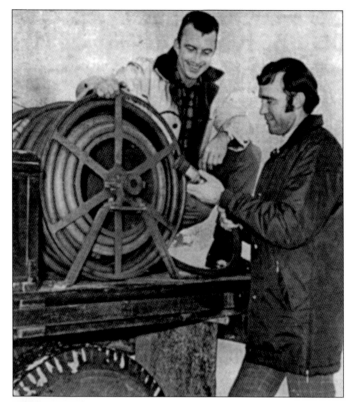

Robert Oscar Bybee lived at the bottom of Combe Road with his wife, Mary Elizabeth Goodwin. He loved baseball and enjoyed it as a spectator. He did his own carpenter work and raised fruits and vegetables. Oscar worked for Utah Power and Light, and lived up in Weber Canyon at the power dam. His job was to keep the right amount of water going down the big wooden pipe to the generator at the power plant. His parents were John McCann and Mary Polly Smith Bybee.

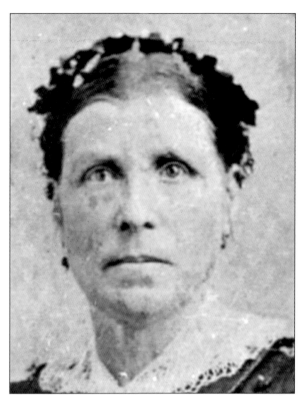

Harriet Choulton Jones was born in 1829 to Geo and Elizabeth Ainsworth Choulton. She came to East Weber in 1861 with her husband, Levinas. Harriet was lame and suffered from it throughout her life. In the spring of 1865, Levinas was gathering wood by the river and fell into a stream and drowned. The next year Harriet met a man by the name of Benjamin Waldron and got remarried. Benjamin was a shoemaker by trade. She watched while East Weber grew from a tiny village with a few farmers to a bustling boomtown when the railroad entered the valley in the late 1860s.

Arthur Henry Combe was born in 1903 and was raised in Uintah up on the flat. His parents were John and Henriett Gardiol Combe. Arthur's father was a dairy man, but Arthur hated to milk cows. His grandfather was in the nursery business, and he chose to follow in his footsteps. He used to follow his grandfather around all the time, learning the techniques that would become valuable for future use. Arthur married Florence Kathleen McDonald, and they started their nursery business in Uintah.

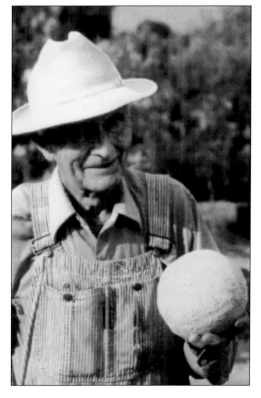

Benjamin Brigham Dye Sr. moved to Uintah with his parents, Jonathan and Charlotte Johnson Dye, when he was three years old. He farmed in Uintah most of his life. When Ben was young, he and Oscar Bybee were out on the Weber River with Joe Beckerton. Joe was standing on some ice fishing, when the ice broke, and he fell into the icy water. When Joe was going under he yelled, "Help, Ben." Ben and Oscar grabbed Joe's hand and pulled him back onto the ice. As soon as Joe was out of the water, he went straight through the field to his home. He never said a word, and he never even caught a cold. Ben married Catherine Georgina Christie and worked for the Union Pacific Railroad as a track watchman for many years. He was killed in Weber Canyon while working for the railroad in 1916.

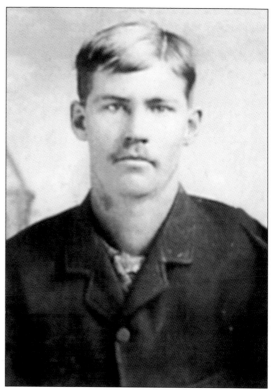

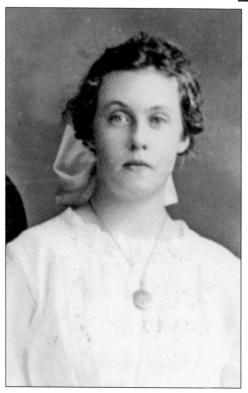

Elva Oretta Stoddard Dye and her parents, William Rookard and Emma Borg Stoddard, moved to Uintah in 1904. She lived in Uintah the rest of her life. She grew up in the redbrick home that still stands today (2010) on Stoddard's Corner at 2250 East 6550 South. This home was built in 1905. Elva attended Uintah School for eight grades. She was married in her parents' home to Jonathan Samuel Dye by Timothy W. Kendell, justice of the peace. When they were married, they had no money and no honeymoon. Elva and her sister, Sarah, would churn cream into butter and would sell it for 50¢ a pound. Elva was active in church and was an election judge for many years. She held the elections in her home for several of those years.

Catherine Georgina Christie Dye was a short lady, quiet and pleasant to be around. She was born in England in 1871 to Samuel and Jane Passfield Christie. She married Benjamin Brigham Dye at a young age, and they raised a large family. She was confined to her home in her older age. They had a little house that set back off the road at 6675 South 2275 East, between the two railroad tracks.

Jonathan Samuel Dye was born in 1893. His parents were Benjamin Brigham and Catherine Georgina Christie Dye. Jonathan married Elva Oretta Stoddard in 1920. He was a farmer and worked for the Utah highways. Jonathan was elected as the first mayor of Uintah in 1937 and served until 1958, longer than any other Uintah mayor. While mayor, he helped in the incorporation of Uintah and the first culinary water system, which was installed in Uintah in 1937. Jonathan donated the property where the new Memorial Park is located. It was taken out of the northwest corner of his farm around 1890 for a place to build a new schoolhouse. The schoolhouse was demolished in 2002.

Ruth Doris Jensen Dye moved to Uintah when she married Henry Carl Dye. Her parents were Arthur and Mary Lucy Rose Jensen. She was a member of the Daughters of the Utah Pioneers and served as a Campfire Girl and 4-H Leader. She painted a large canvas mural of the meeting of the engines at Promontory Point, which was brought to the National Boy Scout Jamboree by the Bonneville Boy Scout troop. In 1965, Ruth became the town clerk and served in that position for many years. In 1974, Ruth designed the insignia for the Uintah town flag. The insignia is still being used today as the city's logo.

Adolph Gilbert Fernelius was born in 1906 in South Weber to Gustaf Adolph and Louis Ann Knight Fernelius. He married Edith Rosella Gustaveson. He was appointed the presiding ecclesiastical officer for the Church of Jesus Christ of Latter-day Saints for 11 years for the South Weber and Uintah Wards, from 1928 to 1938. He had also been the choir leader in both wards.

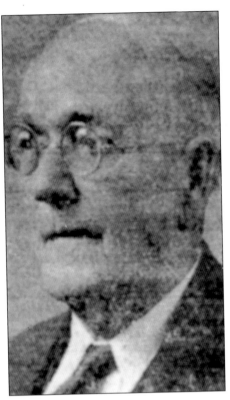

Charles Adolph Fernelius purchased a 120-acre farm in South Weber and worked on the railroad in Uintah. He and his wife, Marie Fredrika Lindberg, joined the Uintah Ward of the Church of Jesus Christ of Latter-day Saints (LDS) because of convenience. He was appointed the presiding ecclesiastical officer for the LDS for 12 years. He was the water commissioner, a farmer, a storekeeper, and a brickyard worker. His parents were Peter Adolph and Maria Gustava Kihlstrom Fernelius. When the U.S. government was confiscating all LDS Church property, Charles was one of three who had the property of the ward put in their names in order to protect it from seizure. He was one of the managers of the Uintah Canning Company.

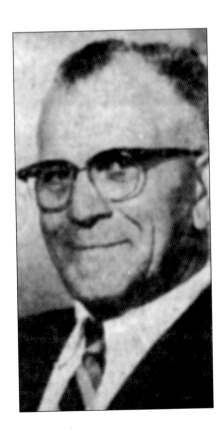

Clarence Walford Fernelius was born in 1893 to John Eric and Eva Palmquist Fernelius. He came to Uintah in 1928 with four people and all of their earthly belongings in a Ford Model T. The trip took two weeks. He helped build the stage in the church house of the Church of Jesus Christ of Latter-day Saints. He also helped put in the town water system and meters. He was custodian of the Uintah School for 10 years. He married Elizabeth (Beth) Williams Keyes, and after her death, he married Minnie Butler Kimball Elwood. Clarence drove the school bus for the kids in Uintah. He was known by the name of "Klinker" to all the school kids. He got the name from driving the many miles to and from school on several rattling, old buses.

Ellen Fredericka Fernelius Stuart was born in South Weber and moved to Uintah when she married Claude Elliott Stuart Sr. Her parents were Charles Adolph and Marie Fredrika Lindberg Fernelius. Together they raised 10 children and two foster sons. Ellen worked in the Church of Jesus Christ of Latter-day Saints and took care of the farm while her husband worked at the Ogden Post Office. She was always ready to help anyone in need. Everyone was welcome in her home, especially the young people. She always had a cookie for the kids when they would stop by. She also supported the town and school events.

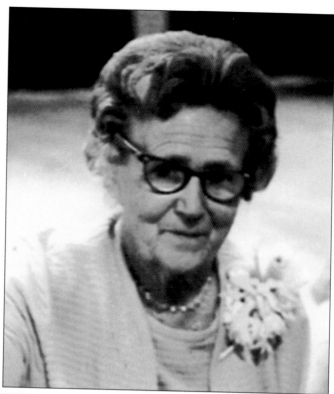

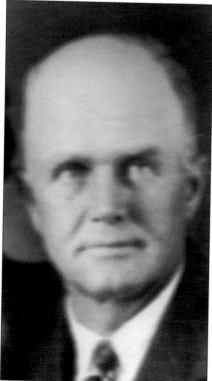

Heber Arthur Fernelius was a man who enjoyed life, liked to talk, and played little tricks on people. He was born in South Weber, which at that time was part of Uintah, in 1884 to Charles Adolph and Marie Fredrika Lindberg Fernelius. He started school when he was nine years old and traveled 2.5 miles to Uintah to attend school. He married Laura May Bybee in 1905. He worked in the Uintah Canning Factory and the canning factory in Morgan, Utah. After that he worked for the railroad, moving from town to town.

Laura May Bybee Fernelius, daughter of Byram Levi and Jane Geneva Robinson Bybee, was born in Uintah in 1885. She was not expected to live when she was a baby. Her sister, Geneva, sat up at nights and watched over her. She remembers watching the Native Americans come into the fruit orchard to gather fruit to dry on their large front porch. She married Heber Arthur Fernelius in 1905. As they moved around, they transferred their household belongings from place to place by horse and wagon until Heber started working for the railroad, and then they put their things in a boxcar. In 1942, they moved back to Uintah and remodeled the old schoolhouse, making it a duplex. They lived on one side and rented out the other. Heber and Laura lived in the older Uintah schoolhouse during the 1940s and 1950s until Heber passed away.

Ronald Dean Fernelius was born in 1928. He is married to Darlene Elizabeth Beard. He worked 28 years in public office. First, he was a city council member for 12 years and then the Uintah mayor for 16 years. While in public office, he donated more than 1 million hours of service, working with council members in their departments and immersed himself in the town's physical projects. Ronald's parents were Heber Arthur and Laura May Bybee Fernelius.

Pamela Stoddard Gale would often go to the nearby stream to catch trout for breakfast for her husband, Robert Moroni Gale. She talked about crickets floating down the Weber River in huge brown masses and crawling into every corner of their house. They had to shake the bedding before going to sleep. She was talented and could do anything. She was widowed at a young age and then raised a second family of two grandsons. She also helped raise the Wattis youngsters. Her parents were Benjamin Franklin and Ann Stubbs Stoddard.

Robert Moroni Gale came to Uintah with his parents, Robert and Rachel Olivia Lightfoot Gale, when he was eight years old. He and his wife, Pamela Stoddard, were active in the community, as well as in the Church of Jesus Christ of Latter-day Saints (LDS). He served in the LDS Sunday school for 47 years, from 1869 to 1916. In Uintah, Robert took care of the deceased. He laid out the dead, dressed them, and prepared them for burial. He would sit up with the dead when no one else was available, and he dug the graves in the cemetery for those who died. There were few families in the town that he did not help, and he never charged anyone for his service.

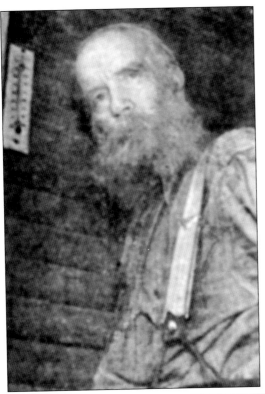

William Henry Gale was born in England in 1859. He married Evangeline Cleveland in 1896 and shortly thereafter moved to Uintah. He was Uintah's self-appointed weather observer for 20 years. He would read the thermometer three times daily, at 7:00 a.m., 1:00 p.m., and 5:00 p.m., and then called to check his figures against those of the official observer in Ogden, Utah. He also kept an accurate diary in which he recorded various war events and the passing of the first airplane through Weber Canyon. His parents were Robert and Rachel Olivia Lightfoot Gale.

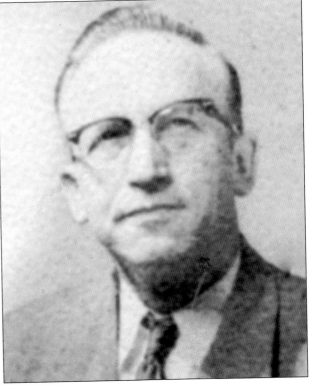

Glenn Hill was raised on the east side of what is now known as South Weber, Utah, in 1906. His parents were Archie Thomas and Elizabeth Harbertson Hill. He married Mildred Hammon. He was appointed the presiding ecclesiastical officer for the Church of Jesus Christ of Latter-day Saints from 1947 to 1953. In 1962, he built and lived in a house at 1993 East 6600 South.

Albert Frederick Kendell's parents were Frederick William and Minnie Catherine Byrne Kendell. He was born in Uintah in 1901, and he married Louelle Jeanette Vogel. He owned a dairy farm in west Uintah at about 1100 East 6600 South. Albert raised his own hay, milked his own cows, processed the milk, and had his own milk delivery route. It was said that he was a fast man, and he would run from place to place delivering milk.

Craig Wynant Kendell was raised in Uintah. He became the sheriff for the Town of Uintah in 1967. He married Linda Kay Rock. He is a deputy for the Weber County Sheriffs. His parents were Russell Dee and Naomi Wynant Kendell. Craig was elected mayor of Uintah in 2002 and served until 2010.

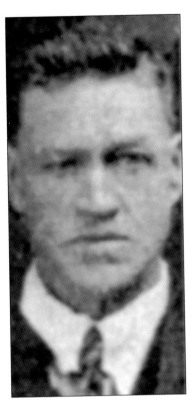

Frederick William Kendell was born in Uintah in 1886. His parents were William and Joanna Peek Kendell. Frederick married Minnie Catherine Byrne in 1892. He farmed in Uintah most of his life. At the time of his death, he was president of the Pioneer Irrigation Canal Company and a counselor in the Uintah Bishopric for the Church of Jesus Christ of Latter-day Saints.

George Edward Kendell met and married Mabel Irene Harbertson in 1915. George owned three different stores and built a house just east of the first Kendell store in about 1935. That house was later moved up to the area known as Kendell Junction. George's son Lenard Kendell and Lenard's wife, Betty, still live in the house that was once the store. George served on the Uintah Town Board in 1937 and was active in the Church of Jesus Christ of Latter-day Saints. His parents were Frederick William and Minnie Catherine Byrne Kendell.

Jay Kendell, son of Parley Prophet and Nellie May Russell Kendell, was Uintah city mayor from 1986 to 1994. He enjoys pheasant hunting and boating. He married Elaine Elmer.

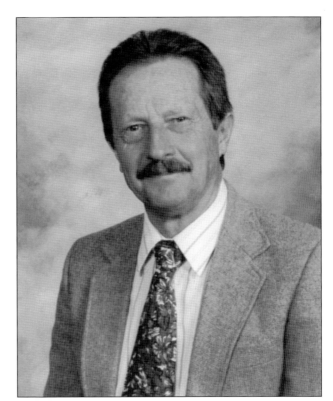

Joanna Peek Kendell moved from South Weber to East Weber in the spring of 1861. Her parents were John and Hanna White Peek. She was familiarly known as "Grandma" Kendell. She endured all the hardships and privations incident to pioneer life. She worked side by side with her husband, William Kendell, who was a farmer and the town butcher. Joanna was a wonderful person to know.

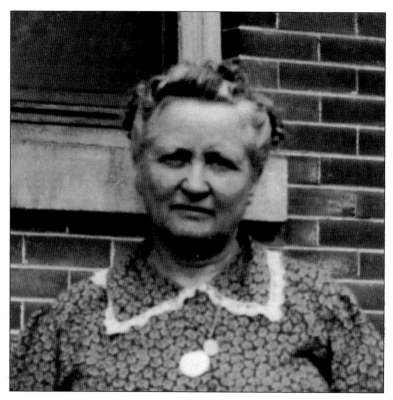

Minnie Catherine Byrne Kendell, a twin, was educated in Piedmont, Utah, and came to Uintah with her parents, Moses and Catherine Cardon Byrne, when she was 16. Minnie was a nurse in Utah and Idaho, and also worked with the Red Cross. Her twin sister, Mary Jane, died at the age of two and a half years old. Minnie married Frederick William Kendell in 1892. She welcomed the youth into their home and would always feed them.

Parley Prophet Kendell was born in 1889 in Uintah. His parents were Timothy and Sarah Ann Prophet Kendell. He liked to tease, was often involved in the activities of the town, and took part in the Uintah Ward shows. He married Nellie May Russell in 1912. He worked for the Union Pacific Railroad survey crew. He served as Uintah's town sexton and as the secretary, treasurer, and water master for the local irrigation company. He and Nellie owned and operated a farm of about 80 acres in Uintah.

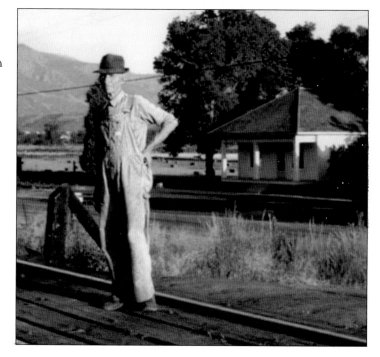

Timothy Kendell was a quiet, gentle man who remained single throughout life. He was born in the Kingston Fort in South Weber, Utah, in 1861. His parents were William and Joanna Peek Kendell. Tim was active in the Church of Jesus Christ of Latter-day Saints (LDS). He was the superintendent of the LDS Sunday school for more than 30 years and Uintah LDS ward clerk for 15 years. In the first general election, he was elected the justice of the peace and held the position for two years. He was then re-elected and held the position for more than 40 years and married many couples. He was one of the directors for the Uintah Central Canal Company and the Pioneer Irrigation Canal Company for 60 years.

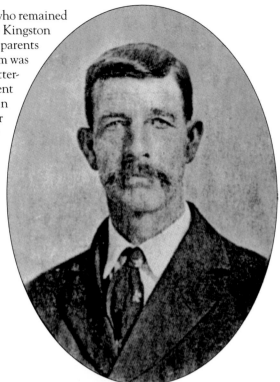

William Kendell, son of William and Sarah Wilkinson Kendell, was born in 1828 in England. He married Joanna Peek, and they lived in South Weber. He was involved in the building of the first schoolhouse in Uintah in 1855 and became a member of the school board after its construction. In 1861, William and his family moved across the river and made their home in Uintah. He started working in 1869 as the town butcher and continued until his death in 1883. He was a successful farmer and stock raiser.

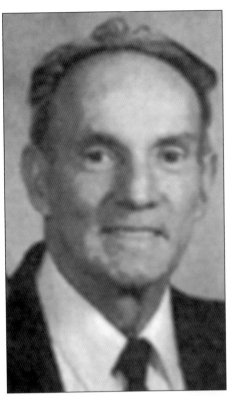

Jack Keyes moved to Uintah when he was two months old. His parents were David M. and Elizabeth Williams Keyes. His father was sick, and his parents moved to Uintah to live with Jack's grandparents. Jack's father passed away when he was only two years old. Life for Jack was hard, but with the help of kind neighbors and friends, he grew up to be a great member of the community. He married Ivy L. Kimber, and together they raised a good family. Jack served for 16 years on the Uintah town council where he helped with several water system upgrades and other improvements in town. He was instrumental in securing water to beautify the Uintah Cemetery.

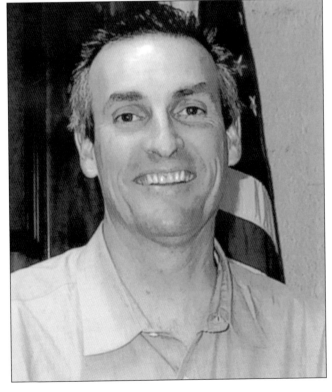

Mike J. Keyes was raised in Uintah. His parents were Jack and Ivy L. Kimber Keyes. Mike works at the Church of Jesus Christ of Latter-day Saints Ogden Temple as grounds facility supervisor. He has been active in Uintah government for several years and has served as U-Day committee chairman for 12 years, city forester for 18 years, Uintah city council member for 5 years, mountain "U" restoration supervisor, and was a member on the city planning commission. He was elected mayor of Uintah in 2010. He is married to Cathryn Ann Sant.

Sherma Stanger Mildon was the Uintah city recorder for 20 years. She started work on June 1, 1988, the same day the old town hall building was open for business. She is married to Luke J. Mildon. Sherma retired as the city moved into its new city hall in February 2008. She worked for four mayors during her 20 years. She is the daughter of Raymond David and Helen Dorothy McFarland Stanger.

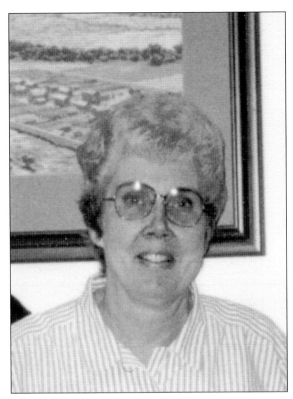

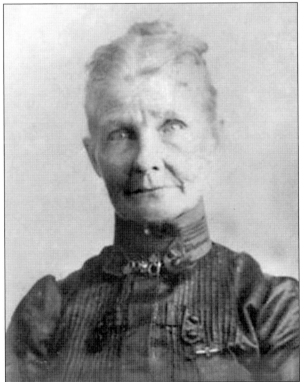

Eliza Pears Summers O'Neil was a small English lady with hair as white as snow and a kind and loving personality. She was the daughter of John Burton and Rosanna Broadhead Pears. Eliza and her mother arrived in Salt Lake in 1856. Eliza married Nicholas Summers as a plural wife one month after her arrival. Nicholas died in a wood-hauling accident. Eliza started working for the Union Pacific Railroad as a cook for the construction crews. This is where she met Timothy O'Neil and married him. They moved to Uintah in 1869.

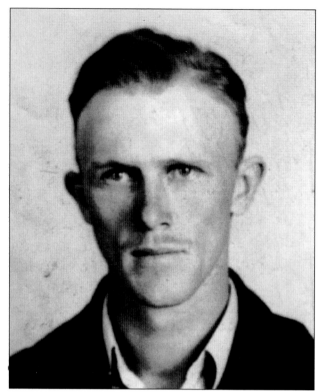

Ralph Edgar Peterson always made time for people. He always had a kind word and a good thought for his fellow man. His parents were John Fredrick and Alta Virginia Keyes Peterson. He took on an adult role early in his life when his father was killed while working on the railroad in 1925. At the age of nine, Ralph helped his mother with his father's funeral. With no money to buy a marker, he made his father's headstone by pouring cement into a wooden box and, with a stick, scratched his father's name and birth and death dates into the stone. Ralph married Irene Mallory in 1938, and they lived on Combe Road and always had a wonderful garden. He served for approximately 15 years on the town council and more than 10 years with the Uintah Mountain Stream Irrigation Company.

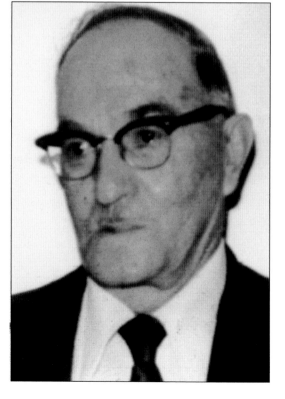

John Milton Pringle, son of Hyrum and Eliza Sophonia Peterson Pringle, was born in 1903. John was active in the Church of Jesus Christ of Latter-day Saints (LDS) Uintah Ward and served 14 years as a LDS ward clerk, from 1958 to 1966. He was appointed as justice of the peace and held the position for four and a half years, handling more than 2,000 cases and performing 34 marriages. He served two years as Uintah Central Canal water master and Town Board of Adjustment chairman for more than 10 years.

Marilyn Roper was raised in Uintah and served on the city council for one year. She was elected mayor of Uintah and served from 1998 to 2002. She is married to Randall Roper, and her parents are Lenard and Betty Kendell.

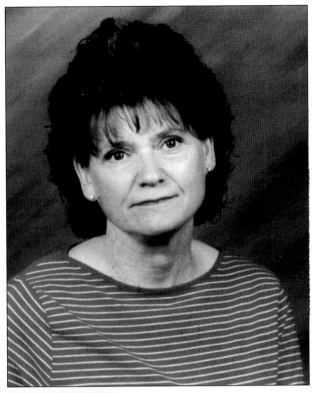

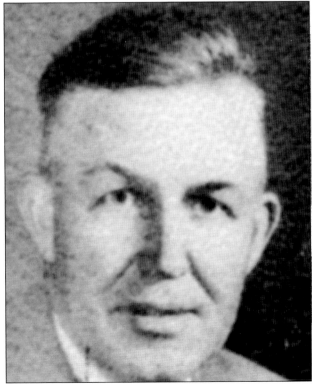

Aldo Richens Stephens and his wife, Emma Marie Lofgren, lived in the most westerly home in Uintah about 1000 East 6600 South, where William O. Knudson lived. He was appointed the presiding ecclesiastical officer for the Church of Jesus Christ of Latter-day Saints during World War II, from 1938 to 1947. He was good for the kids; he did many things for them and is noted for the youth trips he took them on to the High Uinta Mountains. He constructed his own tractor out of an old Ford Model A, putting two transmissions in it end to end. Alto started his own automobile repair business on Wall Avenue. His parents were William Thomas and Hannah Edith Richens Stephens.

Ann Stubbs Stoddard came to Uintah around 1854, when she was sent for by a friend named Willard Glover McMullen. She lived with their family until she was 18, then married Edmond Wattis as a plural wife. After 11 years, she left Edmond and was single for a few years. In 1868, she married Benjamin Franklin Stoddard. She cooked and washed clothes for the Union Pacific Railroad men who were surveying the line for the railroad. During the railroad boom days, her parents, Samuel and Sarah Shaw Stubbs, put up a tent where the Uintah train station was located, and she cooked and sold baked goods such as rolls and cookies.

Emma Borg Stoddard was married to William Rookard Stoddard in Uintah in 1899. He was a railroad worker, and she took care of the farm. She would feed the chickens, gather the eggs, and get the cows down off the hill. Then she would put the cows in the barn, feeding and milking them. She would put the cans of milk in the cool spring ditch to keep the milk cool during the night until they were picked up by the milk truck driver Joe Staples from South Weber, Utah. She had a large raspberry patch that she and others enjoyed. Her parents were Hans Pehrsson and Karna Larsson Borg.

Hyrum Franklin Stoddard had a home that was located at 1943 East 6600 South. He was a farmer, and his wife was Evangeline Cleveland. He was elected mayor of Uintah in 1885 and served until he died in 1889. His parents were Curtis Charles and Lucetta Jane Murdock Stoddard.

Claude Elliott Stuart Sr. was a tall, thin man with gray hair; he was quiet and well liked by the young kids. He married Ellen Fredericka Fernelius, and they raised a large family, including two nephews, David Stuart and Richard Brown. Claude worked at the Ogden Post Office and built a white frame house, located at 6450 South and about 2100 East. He liked to enter contests, and he won many things for his family and home. He was active in the Church of Jesus Christ of Latter-day Saints (LDS) and was the first Boy Scout leader in Uintah. He had a large apple orchard by the old white Uintah LDS church. His parents were David Marshall and Susan Douglas Airmet Stuart.

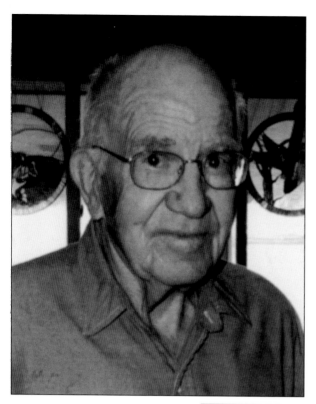

Claude Elliott Stuart Jr. is known for his kindness and the fruit and pumpkins that he sells every year in his yard. He worked for Art Combe when he was young. He married Fay Cramer. He has always been active in the Church of Jesus Christ of Latter-day Saints (LDS). He was appointed the presiding ecclesiastical officer for the LDS Church from 1971 to 1976. He was a Boy Scout leader and started a garbage hauling business with George Garner to earn money to build the Boy Scout house. His parents were Claude Elliott Sr. and Ellen Fredericka Fernelius Stuart.

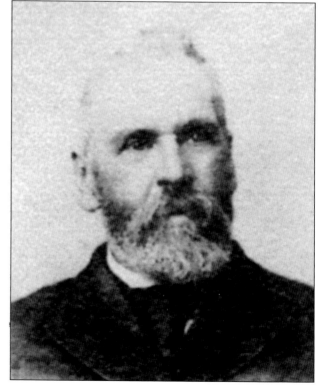

David Marshall Stuart was born in Scotland in 1826. His parents were John and Mary Ann Marshall Stuart. His property was located west of the Valley Nursery. He practiced polygamy and had two wives. One wife, Sarah Keyes, lived in Ogden, Utah, and the other wife, Susan Douglas Airmet, lived in Uintah. He was appointed the presiding ecclesiastical officer for the Church of Jesus Christ of Latter-day Saints from 1884 to 1885.

Five

OUR BUSINESS WORLD

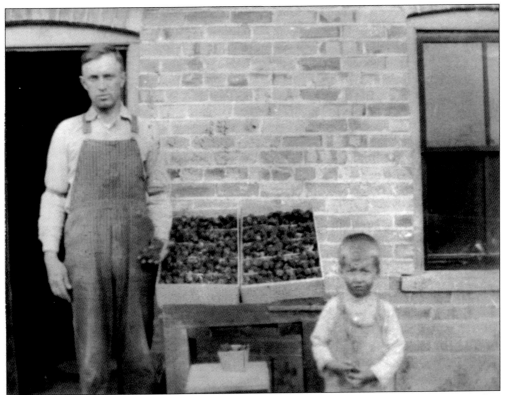

Andrew Anderson (pictured at left with an unidentified child) had one of the first businesses that was started after the railroad boomtown businesses left. He started raising fruits and vegetables that he sold to people in town. The business expanded to where he was shipping produce by railroad to different towns in Utah and Wyoming.

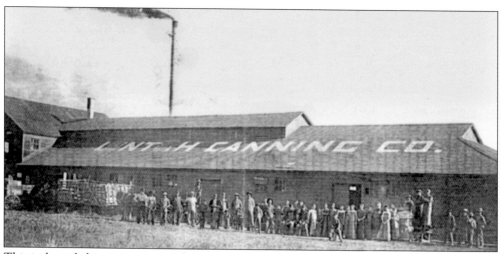

This is the only known picture of the Uintah Canning Company. In June 1901, the cannery was almost complete, carloads of cans were arriving, and farmers were working in the fields. At the end of August, the business started canning tomatoes and pears. The next year, dividends were paid to the stockholders, and the canning company was off to great start. By 1909, only tomatoes were canned. By 1910, the cannery was idle until it was purchased in May 1912. In 1924, the cannery was idle again, with the machinery being sold and shipped away. The building was left empty, and the wood was distributed throughout the area for other buildings.

In 1909, Andrew Anderson became interested in the trout fishery business and started a business called Anderson's Hatchery. This picture shows the head of the ponds, where there were several cold water springs on the property that he owned. Andrew Anderson (left) and Norman Anderson are shown standing at the top of the picture. The children are unidentified.

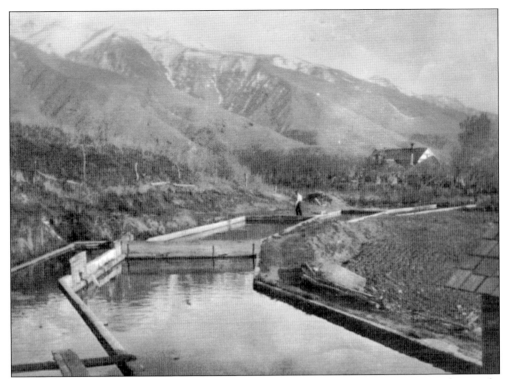

Andrew Anderson built cement ponds and diverted some of the spring water into the ponds. This picture was taken in 1911 and shows the cement ponds. The pond on the left was for the smaller fish.

The above picture was taken in 1914 and shows the ponds. The little building on the left is where they would grind up horse meat to feed the fish. Shown from left to right are Norman Anderson, Andrew Anderson, and Carl Anderson as they feed the fish.

Andrew Anderson raised rainbow trout and sold them to five or six cafés in the area, including the Hermitage and three Chinese cafés. He is shown here gathering the eggs, which he would put back into the ponds to produce more fish. Around 1925, the state highway department enlarged the Dugway over the top of the hatcheries, ending the business.

The image below shows the first Kendell store built by George Edward Kendell in 1925. It was located at 1735 East 6600 South. Later a home was built east of the store.

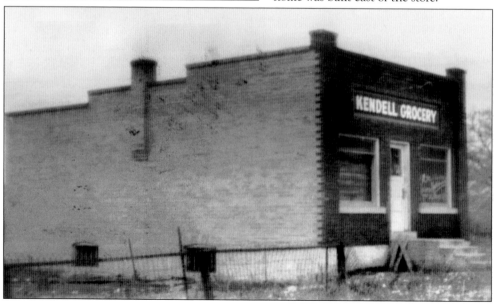

KENDELL GROCERY

This photograph shows the home that was located east of the first store and was moved to Kendell Junction, located in the mouth of Weber Canyon on Highway 89.

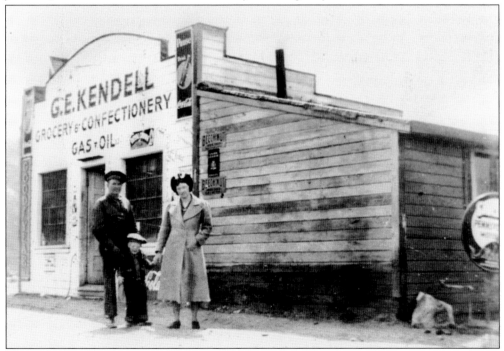

This is a picture of the G. E. Kendell Grocery and Confectionery Store. This was the second store owned and operated by George Edward Kendell. It was located on Highway 89, just below where the Rock Place now stands. Pictured from left to right are George, Max, and Irene Kendell.

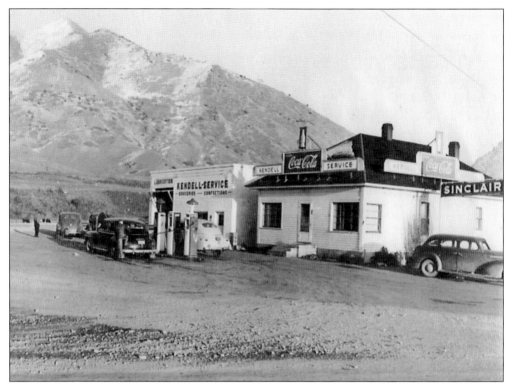

Over the years, Kendell Junction, developed and built by George Edward Kendell, grew. The building on the left was the gas station part. The next building was the home that was moved to the site. This was the third Kendell store, called Kendell Service. It was remodeled into a store and café, with a home at the back where the family lived.

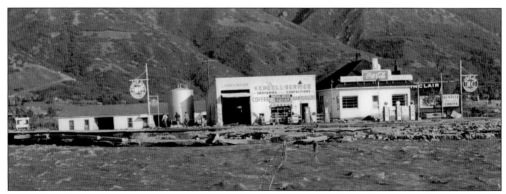

This picture was taken during the flood of 1952. It shows the rest of the development at Kendell Junction. Added to the left was the motel with three units.

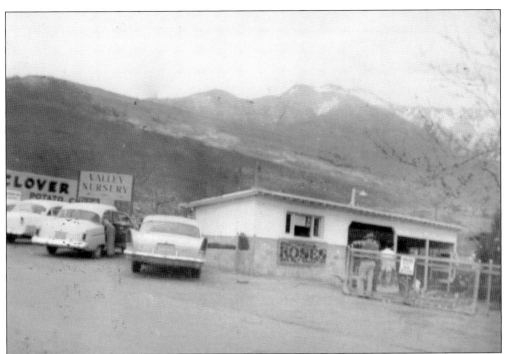

In the spring of 1946, Arthur Combe planted a small nursery in South Ogden, Utah, in the backyard of his brother-in-law's place. He planted fruit-tree seedlings, and then he budded them in the fall with his son, Basil Combe. In the spring of 1947, they were planted in Uintah on Claude Stuart's land behind the old Uintah church. In the spring of 1948, Arthur purchased a small farm in Uintah from Carl Anderson, which is when Valley Nursery was established.

From 1950 to 1954, business was good, and the nursery was growing. It was selling mostly locally grown fruit and shade trees. In 1955, Arthur retired and sold the nursery to his son, Basil Combe, and his partner, Ted Combe. The picture at right shows Arthur (left) and Basil at the nursery. By 1957, Ted Combe decided he would like his own nursery and bought some land near Washington Terrace.

Basil's wife, Shirley Combe, soon took over the accounting, errands, and plant pickup at Railway Express and other freight companies on her way back from the bank. Basil Combe found out that when the fruit farmers came with their wives they were looking for something more than fruit trees. He started adding roses, flowering shrubs, perennials, and annual plants. The picture below shows the enlargement of the nursery to accommodate the growth.

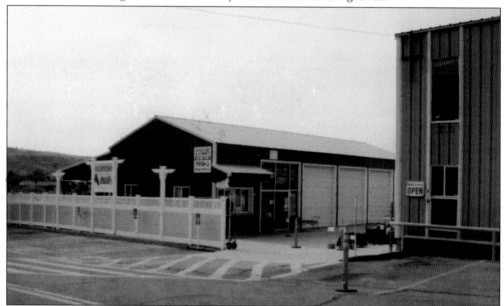

Shown in this picture is the building that was constructed on the west side of the property. At first Basil sold junipers, big blue spruce, and Austrian pine. Now that yards are smaller, the business sells more small pine and spruce, flowering and shade trees, and a considerable amount of perennials and annual plants. But one thing that has not changed is that people enjoy having a good selection of plants.

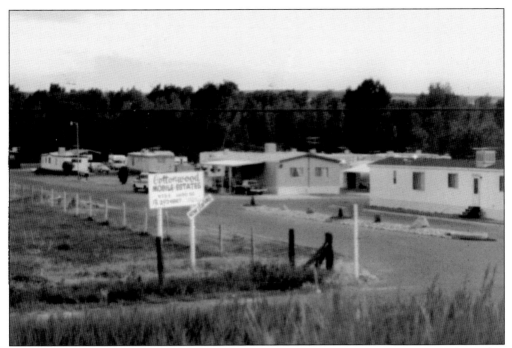

In 1959, William and Jean Knudson bought a track of land that was a swamp near the Weber River and was covered solid with cottonwood trees. They decided to develop the land to provide an income for their retirement. This picture shows the Cottonwood Estates Mobile Home Park when it was developed in 1972.

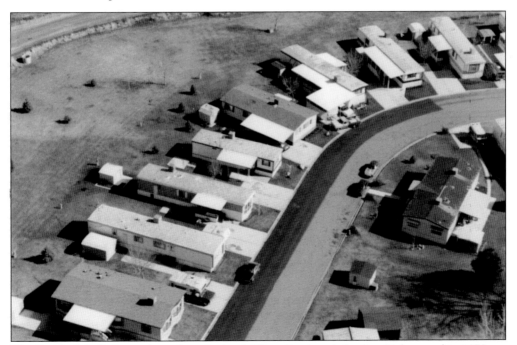

The family did all the work to clear the land. They developed the first 31 lots, and in 1978, an additional 23 lots were added.

Jean and William Knudson built the Cottonwood Estates Mobile Home Park.

The Knudsons bought gallon-sized pine trees from Ted Combe and planted them throughout Cottonwood Estates.

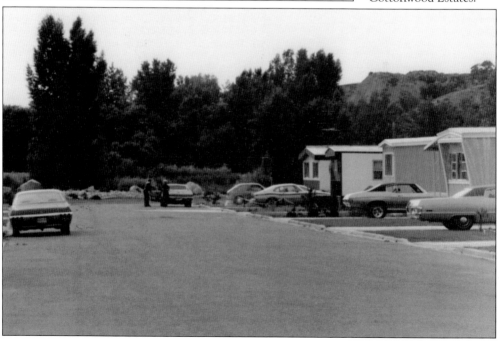

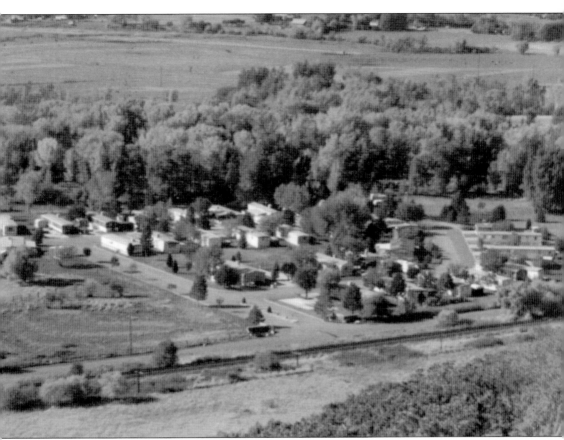

In 1993, an additional 17 lots were added. Cottonwood Estates is considered one of the best mobile home parks in the state.

Ivy Keyes (shown here) started a business in 1969 known as Catering Specialist. The business was a family business because everyone from the small children to the adults helped out. Everything from wedding cakes, receptions, banquet food, and other events that she catered were prepared at her home. Ivy was known in several states for excellent food and traveled throughout Arizona, Idaho, Nevada, Utah, and Wyoming.

Good Cooking Guaranteed
or
Oops...I Cooked the Dishrag!

Written by Ivy L. Keyes

Illustrated and Compiled by Julianne Kimber

In 2004, Ivy Keyes prepared and sold a cookbook with all of her famous recipes.

In the early 1980s, Dixon Pitcher started his business, Pitchers Sports, at his home, selling out of his garage with displays in their backyard. He then moved to a warehouse located in Ogden, Utah, on Twelfth Street. At this point, business was comprised of 80 percent Utah and surrounding states. By opening a retail store in Uintah in 1994, adding a 1-800 line, and using the Internet, his business changed to 80 percent of sales outside of Utah. In 1990, he opened another store in Sandy, Utah.

When schoolteacher Marion Stuart (shown at left), made her first Learning Wrap-up to help her students learn math, she had no idea that someday she would make a million. Learning Wrap-ups, Inc., was started in 1983, patented in 1984, and all done out of her home in Uintah. Much has happened since she carved out her first wooden learning Wrap-up for her fourth-grade students. She no longer teaches but now devotes all her time to selling her creation.

Marion Stuart had an idea, but she had no business or marketing experience. That is when she called the Service Corps of Retired Executives for some guidance. They helped her set up bookkeeping and other business files to get the business started, and it has been successful ever since. In 1988, her firm, located in Uintah, was marketing 21 different teaching aids for math, English, foreign languages, and other educational skills throughout the world.

In 1987, the teaching aid was repackaged in an effort to appeal to the retail market. Wrap-ups were transformed in an "Explosive Learning" game. Her learning devices (shown here) are plastic boards with 12 problems printed on one side and answers across the board, but not in order. A child uses strings to match questions with correct answers. The teaching aids are marketed in foreign countries, with Japan being one of her biggest customers.

The Uintah RV Storage is located on the east side of Highway 89 on 6550 South. The property was originally owned by La Mar and Jessie Barnes, and was the site of Barnes Auto Salvage. Kenneth and Carolyn Barnes purchased the land in 1990 and began clearing and leveling. Over several years, they demolished a number of out buildings and hauled away automobiles, countless car parts, and debris. Uintah RV started doing business in 1992 with space for 50 recreational vehicles.

In 1998, the storage area was expanded to nearly double the number of spaces of the original lot. In February 2005, the lot was expanded to increase the size of the individual spaces and add capacity. In 2007, a separate storage lot (shown here) was opened on the south side of 6550 South, adding more capacity and accommodating larger recreational vehicles.

Founded in 1999, the Rock Place carved out a special niche in the rock industry. These innovative ideas continue to lead the way, with new and exciting products. Pres. Ed Mueller's ideas of a unique rock product have paved the way to what is now known as the Rock Place. The 22-acre retail facility, full of one-of-a-kind products, is located at the base of Weber Canyon in Uintah, Utah. This location also houses a sand-blasting operation, which is the largest in the western United States. The company's slogan, "Where Imagination Rocks," shows the employees' passion about the products they produces.

Beehive Cheese, now an international business, was started in Uintah in 2005. Brothers-in-law Tim Welsh and Pat Ford left the fast-paced world of software and real estate, seeking a more simple way of life as artisan cheese makers. Beehive Cheese is among a few artisan cheese makers in Utah.

Smitty's Tires and Service opened in 2005. Owners Chad Sellers and Roger Smith, with general manager Zackary "Zack" Garn, run the business. Chad and Zack had worked together before they opened up the store. Roger was one of their best customers and had formed a strong friendship with Chad. Together Chad and Roger started the business and brought Zack with them. The name for the store, "Smitty's," came from Roger's father, whose name is Lowell Smith.

Best Western Canyon Pines Hotel opened in 2009. Owner Dixon Pitcher knew that Uintah could have another hotel better than the Snow Flake Hotel during the railroad boom days. He had a vision that a hotel in Uintah would work, and today his hotel features all of the amenities. It is located where Kendell Junction was originally built.

www.arcadiapublishing.com

Discover books about the town where you grew up, the cities where your friends and families live, the town where your parents met, or even that retirement spot you've been dreaming about. Our Web site provides history lovers with exclusive deals, advanced notification about new titles, e-mail alerts of author events, and much more.

Find Your Place in History.